POP
ART

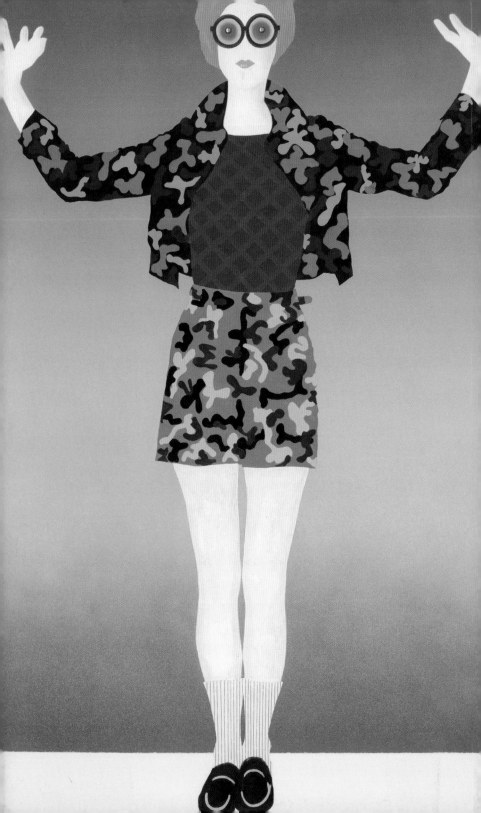

ART ESSENTIALS

POP
ART

—

FLAVIA
FRIGERI

—

Thames & Hudson

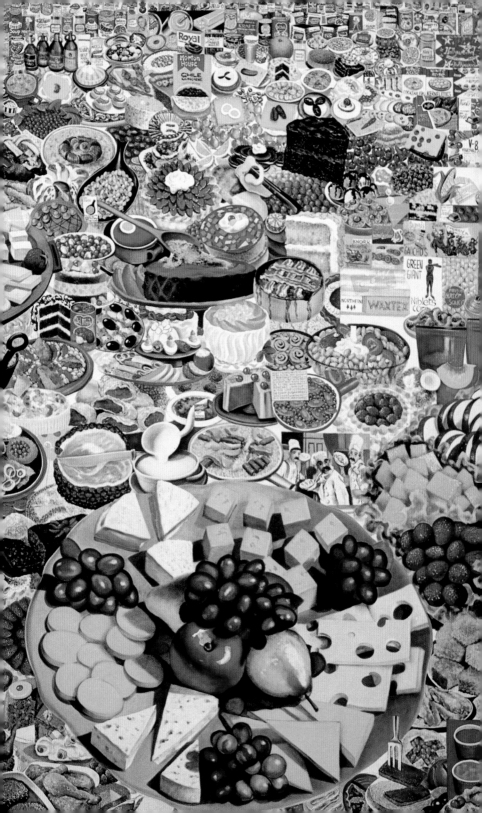

CONTENTS

WHAT IS POP ART?

Pop Art is a post-war movement connecting art with popular culture (Pop is the diminutive for popular). Billboard signs, comic books, movie stars, household appliances and canned food were just some of the subjects chosen by Pop artists to illustrate the contemporary world in which they lived. Mostly coming of age after the Second World War, these artists were only marginally affected by its traumas. Instead they were able to indulge in the product frenzy and image deluge brought about by a rapidly growing consumer society. Supermarkets, with their lavishly coloured packaged goods, offered off-the-shelf inspiration while television provided a window onto an ever-changing cultural, social and political landscape.

Pop is largely characterized by bold and strident colours combined with a cool-eyed appropriation of contemporary imagery from popular sources. Pop artists aspired to replicate the mechanical and inexpressive techniques typically associated with mass culture.

While Pop Art is undoubtedly young, fresh and cheerful, it can also contain a degree of darkness. For example, Peter Saul in his painting *Saigon* (1967; page 64) draws attention to the violence of the Vietnam War. While Erró in his *Foodscape* (1964; page 86) ambiguously celebrates contemporary consumer habits.

Many other Pop works are tainted by ambiguity. The degree to which Pop artists were complicit in or critical of the consumer society that they depicted has long been debated. In bringing to light the myths of their time, Pop artists endeavoured to reveal both the negative and positive facets of contemporary culture.

This book shows that while Pop Art has its roots in post-war American consumerism and the aspirations of British consumers, the language of Pop Art was soon redeployed across the globe as it captured the imagination of young artists.

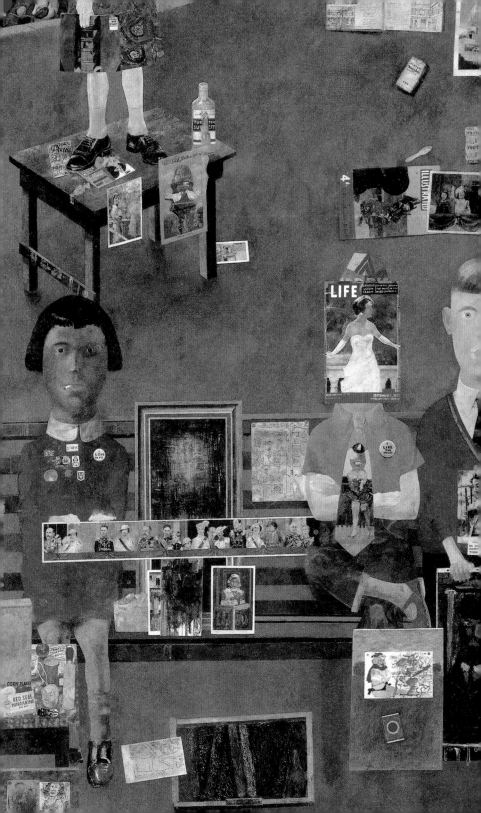

POP BEGINNINGS

-

It's mad, mad, wonderfully mad.
It's also (at different times) glad, bad and sad,
and it may be a fad. But it's welcome

-

Brian O'Doherty

1962

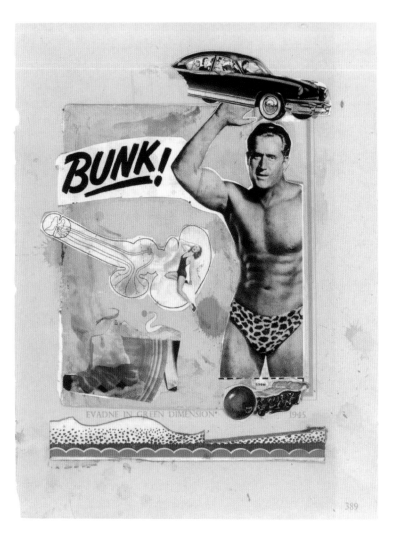

In the beginning Pop Art was British. The movement is rooted in the activities of the British Independent Group, formed in 1952. As Britain emerged from the devastation of the Second World War, advertising in the British media and on London's dreary streets cast its spell over an increasingly affluent society, creating a new consumer culture. The young artists Richard Hamilton and Eduardo Paolozzi, together with the architects Alison and Peter Smithson and the writer Reyner Banham, tried to make sense of this epoch-making shift. They belonged to the Independent Group, which developed out of informal gatherings at the Institute of Contemporary Arts (ICA) in London.

Eduardo Paolozzi
Bunk! Evadne in Green Dimension, 1952
Collage and string on paper, 33.1 x 25.4 cm (13 x 10 in.)
Victoria and Albert Museum, London

Paolozzi plays with images from the American consumer world, such as the blueberry pie and hot dogs. Such foods were aspirational in Britain, where food rationing existed up until 1954.

BUNK!

During one of the Independent Group's first meetings, Paolozzi projected a series of images onto a large screen. Taken from a series of collages made between 1948 and 1950, these images were collated from advertisements, popular magazines, comic books and postcards. They were the first artworks to draw attention to the powerful lure of advertising. Initially conceived as reference images for the artist's own use, the collages, originally shown at the ICA, were published in 1952 as a set of screenprints entitled *Bunk!*

'History is more or less bunk . . . We want to live in the present'

In the 1960s Andy Warhol, one of Pop Art's undisputed leaders, claimed: 'Publicity is like eating peanuts. Once you start you can't stop.' As early as the late 1940s, Paolozzi had commented on the dizzying impact of advertising, as summed up by Warhol. In *Bunk! Evadne in Green Dimension* (1952; opposite), Paolozzi merged a bodybuilding advert with a Ford Motor Company motto: 'History is more or less bunk . . . We want to live in the present.' The present here appears to be inextricably tied up with the profusion of images and the way advertising was redefining contemporary experience. As an early compendium of mass culture's visual repertoire, *Bunk!* shows Paolozzi's prophetic recognition of advertising's pervasiveness, which is one of Pop Art's most recognizable traits.

The Independent Group gave voice to their concerns and fascination with popular culture in the now much-revered 'This is Tomorrow' exhibition held at Whitechapel Gallery, London, in 1956. Although not designed to be a Pop Art exhibition, it still marked

an important step in the movement's formation by highlighting the richness of present-day visual stimuli. The exhibition contained twelve displays, each focusing on different facets of contemporary popular culture, including science fiction and film.

WHAT MAKES TODAY'S HOMES SO DIFFERENT?

In connection with this exhibition, Richard Hamilton made the collage *Just what is it that makes today's homes so different, so appealing?* (1956; opposite). Set in a modern hyper-furnished apartment, Hamilton's collage is filled with the latest gadgets including an over-extendable vacuum cleaner and a television set. Overblown female and male pin-ups straight out of glossy magazines and a comic turned into an artwork hanging on the apartment's wall add to the scene. A theatre or a cinema peeks through the window reminding the viewer that there is plenty out there to keep the masses entertained. The ceiling decoration alludes to the space race that will soon be booming.

This small collage is now widely regarded as one of the first Pop Art works. In it Hamilton, like Eduardo Paolozzi, prophetically raises attention to the products of mass culture through the use of ready-made images lifted from the popular media.

'Popular . . . Transient . . . Expendable . . . Low Cost, Mass Produced, Young . . . Witty, Sexy, Gimmicky, Glamorous, Big Business'

In *Just what is it that makes today's homes so different, so appealing?*, the bulky bodybuilder is shown carrying an oversized lollipop inscribed with the word 'POP'. Despite this mention it is not until the following year that Hamilton consciously uses the term 'Pop'. In a letter to Alison and Peter Smithson, the artist describes Pop Art as: 'Popular (designed for a mass audience), Transient (short-term solution), Expendable (easily forgotten), Low Cost, Mass Produced, Young (aimed at youth), Witty, Sexy, Gimmicky, Glamorous, Big Business.' Hamilton addresses all of the traits that have now come to characterize Pop Art, even though at the time he did so almost unknowingly. His use of the 'Pop' label was confined to art produced for a mass audience, rather than referring to a specific artistic movement.

Richard Hamilton
Just what is it that makes today's homes so different, so appealing?, 1956 Collage on paper, 25 x 25 cm (9⅞ x 9⅞ in.) Kunsthalle Tübingen, Tübingen

Hamilton depicts the consumer fantasy of post-war society. By lifting figures and objects from contemporary advertisements, the artist draws attention to the allure and seduction of contemporary advertising.

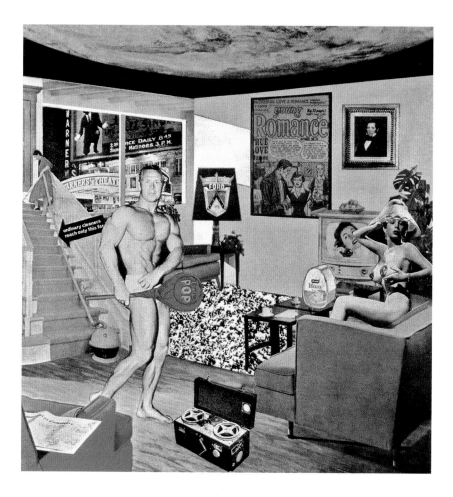

THE EXCITEMENT OF A FAN

The British artist Peter Blake was also enthused with popular culture. Although Blake visited 'This is Tomorrow', and by the late 1950s had made the acquaintance of both Paolozzi and Hamilton, he was not formally affiliated with the Independent Group. Unlike Hamilton, who endeavoured to show the dark side of advertising, Blake embraced popular imagery with the excitement of a fan. As a teenager Blake had shown a keen interest in folk art and images relating to popular entertainment, and his works went on to express his enjoyment for such things, as shown, for example, in his painting *On the Balcony* (1955–7; page 14). Here Blake seamlessly weaves American cultural imports, such as the magazines *Life* and *Weekly Illustrated*, with well-known European masterpieces, including

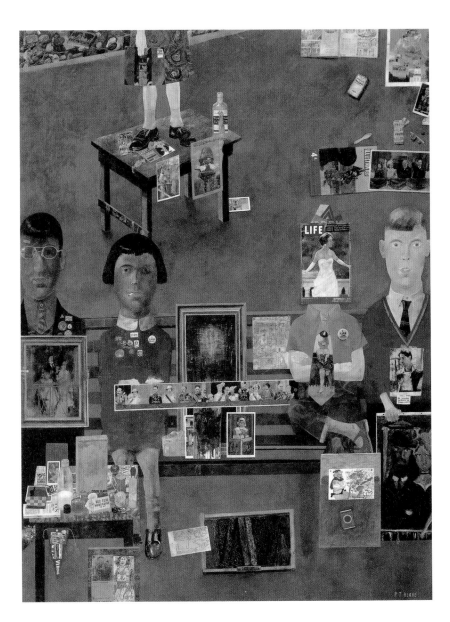

Édouard Manet's *The Balcony* (1868–9). Naive-looking children wearing badges are the protagonists of Blake's painting. The striking patchwork of images, culled from the everyday and crafted by Blake, includes portraits of pop stars and royals; mundane objects like margarine and soda; magazine covers and famous works of art.

Peter Blake
On the Balcony, 1955–7
Oil paint on canvas, 121.3
x 90.8 cm (48 x 36 in.)
Tate Liverpool, Liverpool

Meticulously hand painted, *On the Balcony* is composed of twenty-seven variations focusing on the theme of its title.

-
British artists were forced to negotiate America's bright new ideals
-

Images belonging to different cultural and social milieus are provocatively assembled here, elevating everyday, popular material to the elitist sphere of art. As Paolozzi's *Bunk!* demonstrated, American popular culture, such as magazines, was entering the everyday lexicon of post-war Britain. Like their European Pop peers, British artists were forced to negotiate America's bright new ideals and products with the weight of historical European culture.

ONE-BORN-EVERY-MINUTE AMERICA

Pop Art has been primarily associated with American artists. As Lucy Lippard, one of Pop Art's earliest critical supporters, put it: 'Pop Art is essentially a product of America's long-finned, big-breasted, one-born-every-minute society, its advantages of being more involved with the future than with the past.' Warhol was firmly at the helm of the American Pop contingent. His famed studio, The Factory, was a hub of all things Pop. Roy Lichtenstein, Claes Oldenburg, James Rosenquist, Tom Wesselmann and Robert Indiana were also central to the movement's development.

Pop Art's focus was on the everyday. Insisting on the present and on objective detachment, Pop Art set out to undermine the emotionally loaded abstraction associated with Abstract Expressionism that held sway over the art world in the 1950s. Through a series of exhibitions – mainly in America – Pop Art forcefully became centre stage in the early 1960s. As the art historian John Rublowsky recalled:

The paint can had to be tipped over before the hot dog or comic strip could be considered an object for aesthetic investigation . . . Abstract Expressionism was a turning within; Pop Art is a turning without . . . Democratic, expansive, irreverent, brimming over with confidence and vitality, Pop Art accepts our world and seeks the beauties produced by this world.

Pop Art was initially met with scepticism. Early critics and viewers were put off by its extrovert nature. It appeared too ebullient, jarring, jaunty and shimmering to be taken seriously. With its worship of the Coca-Cola bottle and Campbell's soup can, and its obsession with celebrity culture – embodied most prominently by Marilyn Monroe and the American First Lady, Jacqueline Kennedy – Pop Art was considered trivial at best.

Drawing attention to the scandalous nature of Pop Art, an art critic at the time, Tullia Zevi, asked in a review: 'How evil is Pop art?' and by extension the artists associated with the movement. Answers to this ironic question included, a puzzled 'Who are they?', followed by Zevi's tentative questioning and comment:

Are they geniuses or idiots? Enlightened prophets or impudent crooks? The raw materials chosen among the rubbish of daily necessities is called upon to assume the value of a mystical offering, of a new theology.

Pop artists quickly became the subject of extensive scrutiny. An American critic, writing in the *New York Times*, mocked: 'America has been a pioneer in throwaway cups and saucers, milk containers and tablecloths. Now it is a pioneer in throwaway art.' Despite these early reservations, Pop Art's ascent was fast and furious. American Pop artists, or 'new vulgarians' (as they were loosely termed by an early critic), soon featured in newspapers and glossy magazines. The flat graphic style that mostly characterized their works, combined with an apparently indiscriminate embrace of commercial culture, made Pop palatable to fashionable types, housewives and progressive art dealers. No one could escape the youthful enthusiasm that Pop Art seemed to inspire.

THE AMERICAN WAY OF LIFE

Warhol made Pop's connection with the American way of life and its consumer culture explicit when stating: 'The Pop artists did images that anybody walking down Broadway could recognize in a split second – comics, picnic tables, men's trousers, celebrities, shower curtains, refrigerators, Coke bottles – all the great modern things that the Abstract Expressionists tried so hard not to notice at all.'

Similarly inspired, the artist Robert Indiana pinpointed Pop Art's genesis and repertoire to America, stating:

America is very much at the core of every Pop Work. British
Pop, the firstborn, came about due to the influence of America.
The generating issue is Americanism, that phenomenon
that is sweeping every continent. French Pop is only slightly
Frenchified; Asiatic Pop is sure to come (remember Hong-
Kong). The pattern will not be far from the Coke, the Car, the
Hamburger, the Jukebox. It is the American Myth. For this is
the best of all possible worlds.

While certainly Pop Art owes its existence to the American myth,
here we will see how Pop Art spread its tentacles and its ideals
beyond the United States.

BUBBLE-GUM MAYHEM

Capturing the imagination of many young artists who, like their
American peers, were coming of age in the early 1960s, the
language of Pop Art was redeployed across the globe. For instance,
Marta Minujín embraced Pop ideals early and was catapulted into
stardom in her native Argentina. Speaking of the influence of
commercial art on her work, she later confessed: 'I can only think
of the invention of Bazooka bubble gum as one of the greatest
inventions. Its colour seemed to me the most Pop possible!'
The colour, the material and the novelty of bubble gum was
synonymous for Minujín with the enthusiasm for all things Pop.

**'When you think about it, department stores are
kind of like museums'**

In 1965, in collaboration with Rubén Santantonín, Minujín
created *La Menesunda* (page 19), now one of Argentina's most
celebrated works from the post-war years. Literally meaning
'mayhem', *La Menesunda* consisted of a labyrinth that brought
together sixteen separate and intentionally incongruous
environments. These included a bedroom with a real couple
sitting in bed, a beauty salon complete with beauty products and
attendants ready to give female viewers a makeover, a walk-in
freezer, a room of mirrors, neon corridors, and much more.
Although *La Menesunda* was extremely radical for the rather
conservative artistic tastes prevailing in Buenos Aires, the lure was
too strong to resist. Over thirty thousand people queued to see

Minujín's raucous environment at the Torcuato di Tella Institute. Beyond its playful spirit, *La Menesunda* clearly showed that art was no longer the preserve of stultified museums and could be experienced as part of everyday life. Warhol was of a similar opinion, once stating: 'when you think about it, department stores are kind of like museums.'

Marta Minujín
La Menesunda, 1965
Installation, mixed media

Television was central to *La Menesunda*. Closed-circuit black-and-white televisions allowed viewers to see and be seen.

Pop Art was quickly becoming a global phenomenon

Minujín's sixteen environments, with their over-the-top replicas of domestic spaces and household trophies, such as the walk-in fridge, embodied Pop Art's yearning to turn the everyday into a work of art. This held true for artists around the world as much as it did for American artists. Pop Art was quickly becoming a global phenomenon. From the exuberant appropriation of art historical masterpieces by the Spanish collective Equipo Crónica (see pages 127–9) to the use of the famed Monopoly board game (see pages 58–9) for political subversion by the Swedish artist Öyvind Fahlström, Pop Art could be found virtually everywhere.

KEY WORDS
Independent Group, British Pop Art, consumer culture, popular culture, American way of life, Americanism, Pop beginnings, exuberance, young, fresh, fan-based, criticism

KEY ARTISTS
Eduardo Paolozzi, Richard Hamilton, Peter Blake, Robert Indiana, Andy Warhol, Marta Minujín

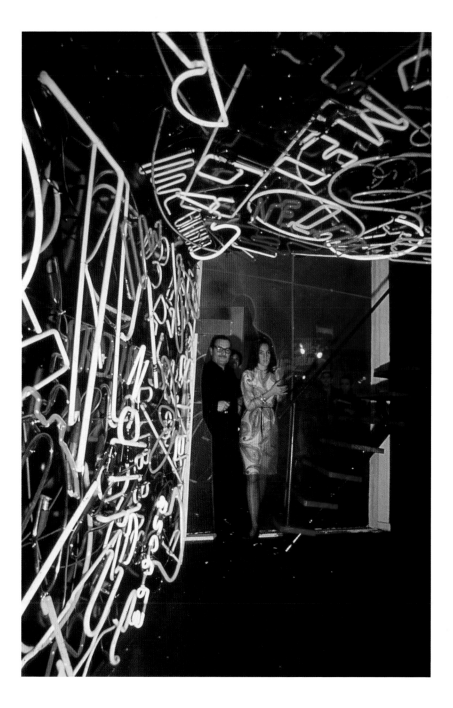

POP STARS

-

**In the future, everyone will be
world-famous for fifteen minutes**

-

Andy Warhol

1968

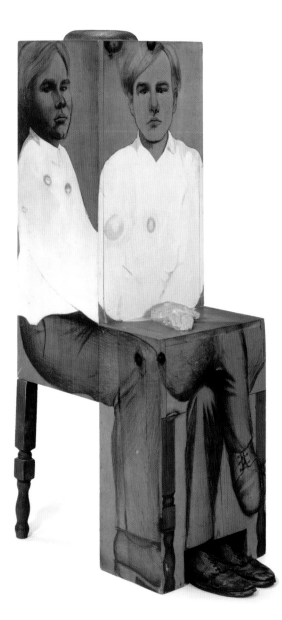

Marisol
Andy, 1962–3
Graphite, oil and plaster
on wood with Andy
Warhol's shoes, 143.5 x
43.8 x 57.2 cm (56½ x
17¼ x 22½ in.)
Private collection

**Marisol's portraits also
included the American
President Lyndon B.
Johnson, the art dealer
Sidney Janis and
the *Playboy* magnate
Hugh Hefner.**

Stardom and glamour were two of Pop Art's most common themes. Andy Warhol famously stated that: 'In the future, everybody will be famous for fifteen minutes.' This was a claim that he personally embraced through his over-the-top artistic persona, unconventional lifestyle, and hip and rowdy headquarters known as The Factory (1962–84). A workspace but also a hang out for artists, socialites, writers, musicians, and many more, The Factory was host to a wealth of legendary parties. A symbol of eccentricity and youthful recklessness, The Factory took part in the craze for stardom projected by Warhol himself. As he later recalled, in his typical deadpan and always subtly ironic way:

I just paid the rent, and the crowds came [to The Factory] simply because the door was open. People weren't particularly interested in seeing me, they were interested in seeing each other. They came to see who came.

Here Warhol underplays his iconic status as, of course, he was sought after like a star. At the height of his advertising career, he was described as 'the Leonardo da Vinci of Madison Avenue', and since then his fame has grown. Obsessed with the myths of his day, Warhol managed, despite his reserved character, to forge a myth around his own persona that outlives him. A Pop idol like no other Pop artist, Warhol's popularity rivals only that of Pablo Picasso.

Warhol pioneered the idea that art was no longer based on uniqueness but could be subjected to industrial replication

FIFTEEN MINUTES OF FAME ON WARHOL'S LAP

Ironically hinting at Warhol's obsession with fame and spectacle is Marisol's *Andy* (1962–3; opposite). Marisol, one of the few female artists associated with American Pop Art, was a regular at The Factory and a protagonist with Robert Indiana of Warhol's experimental film *Kiss* (1963). Of Venezuelan origins but based in New York, she combined the brash and colourful imagery of Pop with the handmade qualities of traditional crafts. Her sculptures, carved in wood and then painted, made wide use of ready-made objects lifted from the everyday, such as teacups, hats, stuffed dogs and purses. In the seated portrait of her friend and peer Warhol, the artist's own shoes are featured in the work. With her sculpture-chair

Marisol ironically points to the possibility for any viewer to take up Warhol's prediction and exploit their fifteen minutes of fame by sitting on his lap.

Marisol's *Andy* can be read as a response to the serial nature of Warhol's portraiture. Adopting commercial methods like silkscreen printing, Warhol pioneered the idea that art was no longer based on uniqueness but could be subjected to industrial replication. Commenting on his working process, Warhol explained:

> I tried to do them [paintings] by hand, but I find it easier to use a screen. This way, I don't have to work on my objects at all. One of my assistants or anyone else, for that matter, can reproduce the design as well as I could.

Delegating the making of the work to assistants, Warhol turned his studio-factory into an assembly line. And by a similar account the endless repetitions to which he subjected the same motifs reflected his enthusiasm for mass production on an industrial scale. In keeping with this production method, Warhol had notoriously and rather ruthlessly suggested that:

> After I did the thing called 'art' or whatever it's called, I went into business art. I wanted to be an Art Businessman or a Business Artist. Being good in Business is the most fascinating kind of art.

The logic of mass consumption, triumphantly upheld in Warhol's work, was irreverently applied to all of his motifs, including his famous celebrity portraits. Featuring an illustrious cast of characters from Elvis Presley to Elizabeth Taylor and Jacqueline Kennedy, these portraits furthered the aura of their glamorous protagonists as well as contributing to Warhol's own fame. *Liz, Elvis* and *Jackie* all existed in multiple versions, and again expressing his commercial approach, he once told an interviewer:

> You see, for every large painting I do, I paint a blank canvas, the same background color. The two are designed to hang together however the owner wants. He can hang it right beside the painting or across the room or above or below it . . . It just makes them bigger and mainly makes them cost more. Liz Taylor, for instance, three feet by three feet, in any color you like, with the blank costs $1600 – signed of course.

Andy Warhol
Marilyn Diptych, 1962
Acrylic on canvas, 205.4 x 144.8 x 2 cm (80⅞ x 114 x 1 in.)
Tate Modern, London

This work, like many Pop portraits, does not fit the parameters of conventional portraiture as Monroe never sat for it.

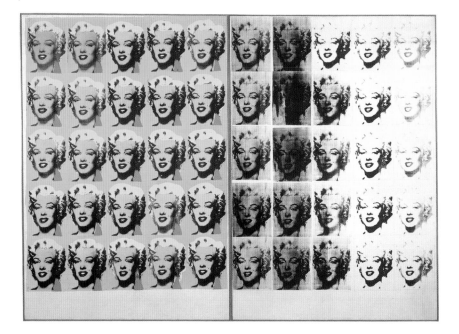

Sounding more like a supermarket offer than an art transaction, Warhol treated his subjects as products of the contemporary cultural industry that could be bought and sold with great ease. Undoubtedly Marilyn Monroe was the star he exploited the most.

MARILYN MONROE

Overleaf: Richard Hamilton
My Marilyn, 1965
Oil and collage on photographs on panel,
102.5 x 122 cm
(40½ x 48 in.)
Ludwig Forum für Internationale Kunst, Aachen

The 'my' of the title suggests Hamilton's dual desire to appropriate the photographs of Marilyn as well as the star herself.

Marilyn Monroe was represented as the archetypal sex bomb, a label she was never able to escape. Her blondness has often been equated with dumbness, and the roles she played consistently portrayed her as a sex symbol. While her comic talent was fully made use of in blockbuster Hollywood movies, she confessed that not being cast for more serious parts was a source of disappointment. Since her untimely death caused by a sleeping pill overdose on 5 August 1962, her fame has consistently escalated. Warhol has played a significant role in furthering the Marilyn myth and its longevity. Of particular fascination to Warhol was the combination of fame and tragedy that Monroe embodied. Embarking on his iconic series of *Marilyns* only after the actress's death, Warhol depicts Monroe at the height of her success. With her blond bob and forced smile she is presented at her most stereotypical.

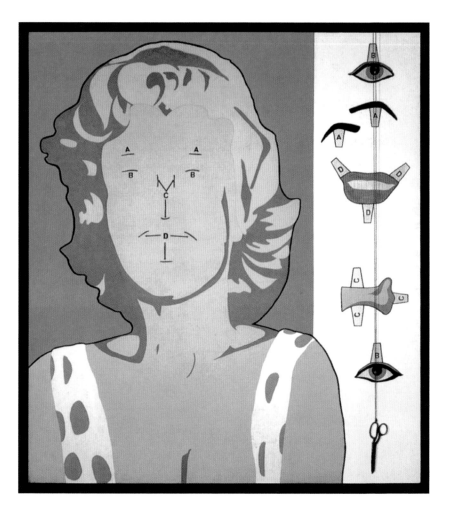

Warhol's portraits in their infinite variations were based on a photograph of the actress used in the promotion of the 1953 film *Niagara*. By flattening this image further through the silkscreen process, Warhol created a series of works aimed at exposing the illusion surrounding the actress's public persona.

The *Marilyn Diptych* (1962; page 25) in particular brings to light the ubiquitous nature of Monroe's image. A regular fixture in magazines and newspapers, the actress was instantly recognizable, and the repeated portraits in Warhol's work nod to this. The neighbouring coloured and black-and-white sections also point to the contradictions of Monroe's persona. Both a gleefully coloured sex symbol and a fading black-and-white icon, Monroe is simultaneously revered and questioned here.

Following on the heels of the *Marilyn Diptych* is *Gold Marilyn Monroe* (1965), in which Warhol sets his by-then familiar image of Monroe against a gilded background. The golden aura surrounding Monroe ironically furthers her mythical standing. Despite presenting her as a latter-day goddess, Monroe is ultimately just one of many stars in Warhol's catalogue of celebrities, there to be consumed.

-

Marilyn is handed over to the viewer as a toy that can be assembled and disassembled

-

Many other artists, including Richard Hamilton, were inspired by the icon Marilyn Monroe. Also seeking to expose the constructed nature of her image, Hamilton based his collage *My Marilyn* (1965; pages 26–7) on a series of shots taken by the photographer George Barris. Published posthumously, the images reveal Monroe's input in selecting which photographs were appropriate for publication and which were not. Crosses and ticks neatly distinguish good ones from those that are to be cast aside. Hamilton takes the process one step further by manipulating the images himself. With his coloured brushstrokes the artist rejects some of the languid vitality that characterizes Monroe's otherwise flirty posing.

Like Hamilton, the American artist Allan D'Arcangelo plays with Monroe's defacement. Taking a frontal image of the actress in *Marilyn* (1962; opposite), he systematically removes her facial features – eyes, nose, lips and eyebrows – and places them to one side. D'Arcangelo's *Marilyn* is handed over to the viewer as a toy that can be assembled and disassembled at one's leisure. The artist comments here on the artificiality of celebrity beauty.

Allan D'Arcangelo
Marilyn, 1962
Acrylic on canvas with string and scissors, 152.4 x 137.2 cm (60¾ x 54 in.)
University of Buffalo Art Galleries, Buffalo

Monroe is featured here as a cut-out paper doll, removing all sense of individuality and turning her into a bland commodity.

SWINGING LONDON

American movie stars were not alone in the pantheon of Pop Art's contemporary gods and goddesses. In his *Swingeing London 67 II* (1968; above), Hamilton turned to a photograph found in the *Daily Mail* showing Mick Jagger from the Rolling Stones handcuffed to the art dealer Robert Fraser inside a police vehicle. Though both were charged with drug possession, this infamous episode ended with a six-month sentence for Fraser and a conditional discharge for the singer-idol Jagger. Although Hamilton had no direct involvement in the event, he was nevertheless indirectly affected as Fraser represented him.

Swingeing London 67 II reads both as commentary on a contemporary event and as a site of experimentation

Hamilton made a poster assembling a range of newspaper cuttings, each offering different perspectives on the episode.

Richard Hamilton
Swingeing London 67 II,
1968
Oil on canvas and
screenprint, 67 x 85 cm
(26 x 33½ in.)
Museum Ludwig, Cologne

**By appropriating popular
images, like the one
featured in this work,
Hamilton implicitly drew
attention to the process
of image-recognition
ignited by the media.**

He then extrapolated from this poster an image that he revisited
six times in his *Swingeing London* series, which owes its title to the
judge's verdict in court: 'There are times when a swingeing sentence
can act as a deterrent.' Thus while *Swingeing London 67 II* reads as
commentary on a contemporary event, it should also be understood
as a site of experimentation for Hamilton who proposed six different
takes on this event.

LOOK MICKEY

Stardom concerned not only the living and breathing heroes and
heroines of the day like Monroe, but also encompassed fictional
characters like Superman, Donald Duck and Mickey Mouse. On
view as much as Hollywood celebrities, comic-book characters
entered the repertoire of Pop Art instantly.

**Magnifying a comic strip may appear a banal gesture today,
but in 1961 it was considered a provocative move**

Roy Lichtenstein, one of the titans of American Pop Art, in his
Look Mickey (1961; page 32) appropriated a comic strip featuring
the Disney characters Donald Duck and Mickey Mouse. Supposedly
challenged by one of his two sons who, pointing to a comic, said:
'I bet you can't paint as good as that', Lichtenstein went on to mimic
the mechanical style of the original source so admired by his son.
Soon to become the hallmark of Lichtenstein's work, the Benday-
dot pattern used for half-tones in comic strips retains a degree of
being crafted by hand, as does the picture as a whole. Later works
were to be subjected to a process of increased mechanization,
as shown in *Drowning Girl* (1963; page 111).

Magnifying a comic strip panel may appear a banal gesture
today, but in 1961 when Lichtenstein created *Look Mickey*, it was
considered a provocative move. As Lichtenstein later confessed:

The first painting I did in 1961 is called *Look Mickey*, and of
course I realized that this was a marked change from prevailing
taste . . . I adopted the idea of simulated cartoon printmaking
just to try out the idea. I hung this work up in my studio to think
about it, but I was unable to go back to abstraction, which had
been my intention, because this cartoon painting just seemed
too demanding.

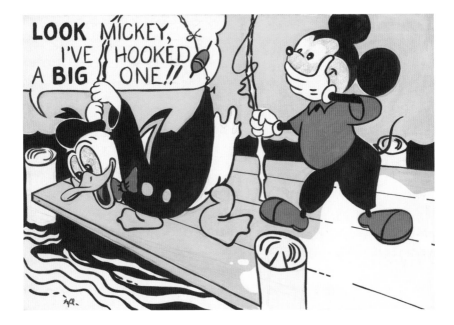

Roy Lichtenstein
Look Mickey, 1961
Oil on canvas, 121.9 x
175.3 cm (48 x 69 in.)
National Gallery of Art,
Washington, DC

**The cartoon is taken
from an image in one
of the Little Golden
Books belonging to
the artist's children.**

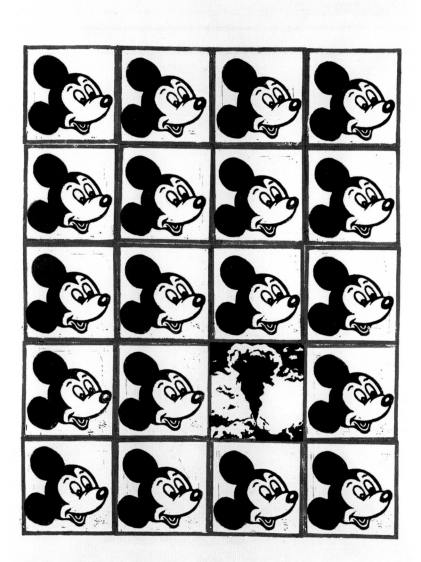

Equipo Crónica
América, América, 1965
Lineoleography,
100 x 70.4 cm
(39 x 28 in.)
Institut Valencià d'Art
Modern (IVAM), Valencia

Equipo Crónica's prolific
production included
prints, postcards,
calendars and comics.

Unlike Lichtenstein's earlier experiments with Abstract
Expressionism, *Look Mickey* united art and popular culture. It
celebrated Disney heroes rather than expressing the artist's
inner emotions.

MICKEY GOES ATOMIC

The Spanish collective known as Equipo Crónica, formed in 1964
by Rafael Solbes, Manolo Valdés and Juan Antonio Toledo, were
also drawn to the myth of Mickey Mouse. *América, América* (1965;
page 33), one of Equipo Crónica's early works, features the famous
Disney character. However, unlike Lichtenstein's cheerful take on
Mickey and Donald fishing, Equipo Crónica's use of Mickey has
more explicit political overtones.

In the same way that Warhol subjected Monroe to repetition
in his *Marilyn Diptych*, Equipo Crónica replicated Mickey's smiling
black-and-white portrait repeatedly in *América, América*. The
influence of Warhol's serialization is clear, but the intention here
is very different. The explosion of the atomic bomb amid the
smiling Mickeys hints at the human and material damage caused
by American attacks on Hiroshima and Nagasaki at the end of the
Second World War. Similarly, the presence of the American-born
mouse embodies America's imperial ambitions in the post-war
era. In *América, América*, Mickey goes from innocent cartoon to
political stand in for America's prosperity and its domineering
foreign policies.

BATMAN CONFIDENTIAL

I got my MA in 1958 and I was doing figure paintings – one
single isolated figure . . . It stayed that way for about two years,
until 1960, when I really sort of said 'fuck art, I'm not going to
do that shit any more'. I'm just going to do what I want to do,
so I painted some pictures of Batman.

This is Mel Ramos speaking in an outburst of honesty, rejecting
the stultified academic painting that he had been practising up until
1960. Through turning to the 'comic heroes that meant a lot to
me when I was a kid', Ramos aspired to emulate the visual appeal
of comic-book culture. Unlike Equipo Crónica's Mickeys, Ramos's
superheroes were not charged with any particular political feat; they
were simply heroes. Painted through the eyes of an enthusiastic

Opposite:
Mel Ramos
Batmobile, 1962
Oil on canvas, 127.5 x
112 cm (50 x 43¾ in.)
Museum Moderner Kunst
Foundation Ludwig,
Vienna

**Ramos studied at
Sacramento State College
under Wayne Thiebaud
who encouraged his
students to explore the
possibilities of paint.**

Overleaf:
Tanaami Keichii
Comic Strip, 1967
Comic, magazine scrap,
printed photograph
collage on drawing paper,
32.5 x 48 cm (13 x 19 in.)
Private collection

**This work is made of
cut-outs from a variety
of different comic strips.**

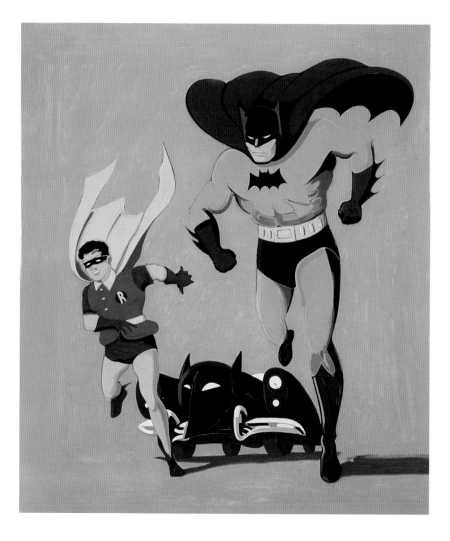

fan, Ramos's Batman, Wonder Woman and Superman were
quintessential icons of popular culture turned into artworks.

**Ramos is fascinated here with the heroic feats
of these fantastical characters**

In *Batmobile* (1962; page 35) the emphasis is placed on Batman
and Robin leaping out of the customized and heavily accessorized
Batmobile. Running towards the viewer, the two characters are
poised to spring into action against the latest evil. Victory is no
doubt assured. The heroes, like classical gods, are constantly
accompanied by an attribute; in this case it is the Batmobile, which
gives the painting its title. Unlike Lichtenstein, who was drawn to
the flatness and other material qualities of comic strips, Ramos is
fascinated here with the heroic feats of these fantastical characters.
Incredulous that what had meant a lot to him as a child could
actually be commercially viable, Ramos recalled:

> Before I knew it, I had about forty paintings like that, and I didn't
> know quite what to do with them, so I sent some slides to a guy
> that was recommended to me in New York. He started selling a
> few, and when he started selling paintings that you never really
> thought you could sell, it really does something to you.

SUPERMAN
Like Ramos, the Japanese artist Keiichi Tanaami was fascinated by
the world of comic books, with its unbeatable heroes and heroines.
Tanaami was not just a fan of comic strips: he was also a well-known
illustrator. Much like Warhol, whose Factory he visited in 1968,
Tanaami made a name for himself in advertising and graphic design.
The first art director of the Japanese edition of *Playboy* magazine
and the illustrator for the cover of records by The Monkees and
Jefferson Airplane, Tanaami consistently turned to the comic-strip
aesthetic.
　　Tanaami's *Comic Strip* (1967; pages 36–7) reads as a tribute to
comic-book culture, and its repertoire of figures, from Batman to
Superman. As a teenager the artist was enraptured by American
popular culture and the influx of American exported products, such
as Disney animations and Hollywood films, that he encountered
in post-war Japan. While the visual legacy of America had an

undeniable impact on Tanaami, the artist maintained an ambivalent attitude towards the United States. Still vivid in his memory was the traumatic experience of the Second World War and the American air raids over his city Tokyo that he experienced as a child. These memories never left Tanaami, tainting his perception of America long after the end of the war.

-

The comic-strip heroes appear powerless in the face of such senseless evil

-

As a consequence, the artist frequently turned to war and its visual impact in his comic strips and animated films. *Comic Strip* in particular shows a reverence for Superman and Batman, but also points to the destruction left behind by the US attacks. At the bottom of the collage is a dump, which brings to mind the ravished landscape of Japan following American bombardment. The heroes appear powerless in the face of such senseless evil.

KEY WORDS

Stardom, glamour, Pop idols, celebrity portraits, Swinging London, Atomic bomb, comic books, The Factory, teenage culture, heroes and heroines

KEY FIGURES

Marilyn Monroe, Mick Jagger, Donald Duck, Mickey Mouse, Batman, Superman, Wonder Woman

KEY ARTISTS

Andy Warhol, Marisol, Allan d'Arcangelo, Richard Hamilton, Equipo Crónica, Roy Lichtenstein, Mel Ramos, Keiichi Tanaami

POP POLITICS

-

We stand today on the edge of
a new frontier – the frontier of the 1960s,
a frontier of unknown opportunities and perils,
a frontier of unfulfilled hopes and threats

-

John F. Kennedy

1960

Before the emergence of mass media, history painting visualized for posterity the feats of illustrious men, royal courts and epic battles. With the rise of printed matter, and even more so with the spread of television, images became far more accessible. This sudden surge of readily available images offered Pop artists an unrivalled opportunity to reinterpret contemporary history. The most prominent political figures of the day – from the young and charming President of the United States John F. Kennedy to the founding father of the People's Republic of China, Mao Zedong – entered Pop's vocabulary. Treated on a par with Marilyn Monroe and Donald Duck, these and many other political leaders, as well as noteworthy events, were instantly captured by Pop Art. By chronicling key facts and figures, Pop Art acted as a visual and historical record of its day.

Andy Warhol
129 DIE IN JET!, 1962
Acrylic and pencil on canvas, 254 x 182.9 cm (100 x 72 in.)
Museum Ludwig, Cologne

Warhol appropriated and replicated the style and layout of a black-and-white newspaper.

129 DIE IN JET!

On 3 June 1962 an Air France Boeing 007 crashed during take-off at Paris Orly Airport. With the exception of two people, the 122 passengers, as well as members of the flight crew, perished in the fatal departure. This was the world's most devastating aircraft disaster up to that point. The crash made headlines worldwide, especially in America, as the bulk of the passengers belonged to the arts elite of Atlanta on a month-long tour to visit Europe's cultural treasures. Andy Warhol replicated the front cover of a newspaper announcing the deaths in his *129 DIE IN JET!* (1962; opposite). Black and white like an expendable daily, Warhol's take on the fatal accident is intentionally deadpan. Deprived of any emotional commentary, it presents the news as a fact and nothing more. Later commenting on the making of this work the artist confessed that it was the constant presence of death in news articles that first drew his attention to this specific cover. He said:

> I guess it was the big plane crash picture, the front page of a newspaper: 129 DIE. I was also painting the Marilyns. I realized that everything I was doing must have been Death. It was Christmas or Labor Day – a holiday – and every time you turned on the radio they said something like '4 millions are going to die'. They started it. But when you see a gruesome picture over and over again, it doesn't really have any effect.

An account of death, as much as a comment on the capacity of images to numb viewers through endless replication, this work acted as a link to Warhol's portraits of Marilyn Monroe (pages 25–9).

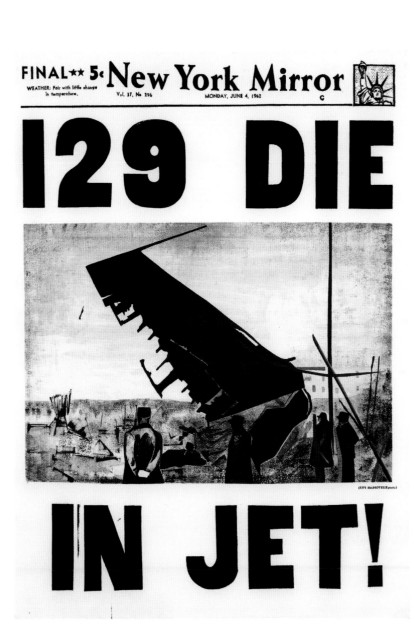

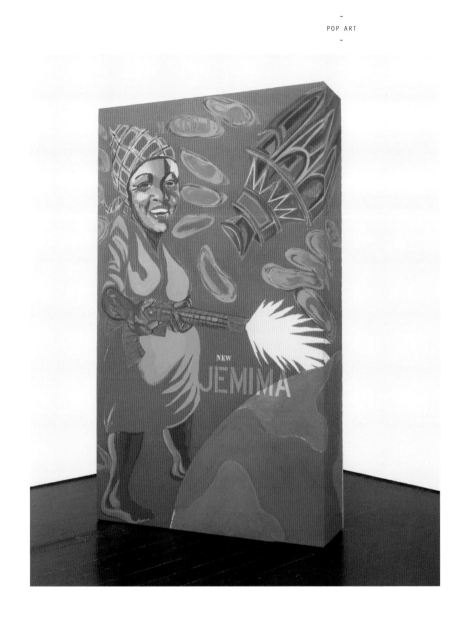

HOORAY! IT'S AUNT JEMIMA DAY!

One of the advertisements for a famous pancake mix branded Aunt Jemima proclaimed, 'Hooray! It's Aunt Jemima Day!' and featured a reassuring and friendly black woman on its logo. Another advertisement for the same product preached, 'all you need is a wish and a few pennies to make the world's most delicious pancakes'. An Aunt Jemima pancake thereby appeared as an affordable common good that could be purchased from any supermarket. In *The New Jemima* (1964–70; above), the African

American artist Joe Overstreet turned the innocent Aunt Jemima into a civil rights heroine. Recalling the genesis of this unlikely character, Overstreet stated:

> I read in a magazine that Nancy Green, who was born in slavery in Kentucky, cooked around a million pancakes at the 1893 Chicago World's Exposition in order to save a pancake flour company. She made me think of my grandmother, my mother, and I thought she must have been tired. And I knew Jemima was tired of that role. The painting – *The New Jemima* – has a double meaning. So my painting reveals the New Jemima who chose a machine gun as her stove, for her kitchen equipment.

The New Jemima stands as an emblem of the struggle for equality

In *The New Jemima* the familiar pancake-mix box is blown up to over two metres in height. Depicting a giant Jemima brandishing an assault rifle and firing pancakes at an out-of-sight target, Overstreet's work is a call for action. A fictional member of the civil rights movement, Aunt Jemima points to the struggles endured by the African American community, segregated and discriminated against racially. *The New Jemima* stands as an emblem of this struggle for equality. From a passive domestic aide to the white middle-class families purchasing the pancake mix for just a few pennies, Aunt Jemima is turned here into a reckless fighter.

RIOTS AND LEADERS

Artists Joe Tilson and Warhol also commented on the struggle for civil rights. While both turn to printed media to record this pressing matter, they do so in starkly diverging ways. Warhol adopts his customary deadpan appropriative style to depict a brutal riot that took place in the American South during a civil rights campaign. Using an image of the event from *Life* magazine, Warhol replicates the photograph a number of times in no specific order in his *Red Race Riot* (1964; page 46). The goal, as with *129 DIE IN JET!*, is to convey the banality of death, disasters and violence – now everyday occurrences in American society.

By contrast, in *Page 18: Muhammad Speaks* (1969–70; page 147), Tilson crafts out of wood and plush handmade cushions a fictitious newspaper cover. This work belongs to a series classified by

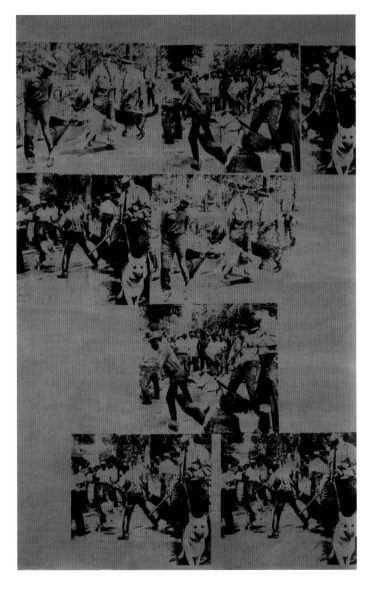

Andy Warhol
Red Race Riot, 1964
Acrylic and silkscreen ink
on canvas, 348 x 210 cm
(137 x 83 in.)
Museum Ludwig, Cologne

Policemen are shown
attacking the protesters
with dogs and fire hoses.
Warhol's source image
was a photograph of a
violent event that took
place in Birmingham,
Alabama.

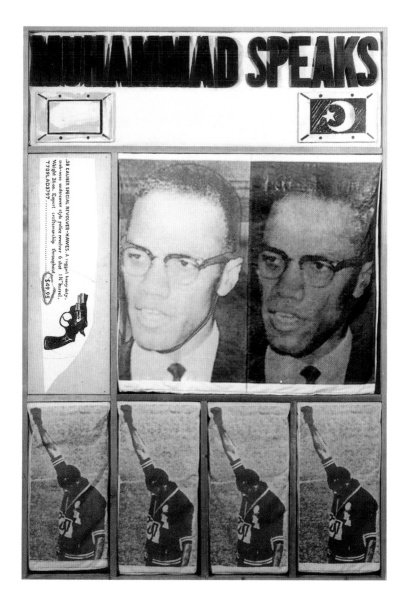

Joe Tilson
Page 18: Muhammad Speaks, 1969–70
Screenprint and oil paint on canvas on wood relief, 186.7 x 125 cm (75⅝ x 50 in.)
Private collection

The tactile and homemade quality of this picture sets Tilson apart from the hard-edged aesthetic of Warhol's Pop. However, like Warhol, he captures history in the making.

handshake and promise of a brighter future was captured on camera and televized across the nation, bringing the future president to people's living rooms on a scale that voters had never experienced before. Thanks to television and other media, images of JFK quickly became ubiquitous. Pop artists did their share in spreading the President and his wife's mythology.

Rosenquist aspired to be a painter rather than a simple image duplicator

James Rosenquist, a native of Minnesota and a successful billboard painter, chose JFK as the subject of his first easel painting. In *President Elect* (1960–61; opposite), Rosenquist combined a presidential campaign poster with a piece of cake and a car advertisement. The three images, all taken from different sources, seamlessly merge thanks to Rosenquist's skilful technique. Painted in a detached way typical of commercial painting, Rosenquist nevertheless maintained an interest in the painting process. Unlike Warhol, who had adopted the more mechanical silkscreen method, Rosenquist aspired to be a painter rather than a simple image duplicator, as he pointed out:

I learned a lot about painting paint when I painted signs. I painted things from photos and I had quite a bit of freedom in the interpretation, but still, after I did it, it felt cold to me, it felt like I hadn't done it, that it had to be done by a machine. The photograph was a machine-produced image. I threw myself at it. I reproduced it as photographically and stark as I could. They're still done in the same way; I like to paint them as stark as I can.

Referring here to his paintings, Rosenquist clearly stated how he sought to replicate machine effects by hand. Minutely conveying the detachment of photography, he subjected advertising imagery to a quasi hyper-realist treatment. What remains most notable, though, in Rosenquist's paintings are the juxtapositions he created between seemingly incongruous elements. These stem directly from the ways in which people have become accustomed to absorbing multiple images at a time. Rosenquist commented:

I'm amazed and excited and fascinated about the way things are thrust at us, the way this invisible screen that's a couple of

James Rosenquist
President Elect, 1960–61
Oil on Masonite, 228 x
366 cm (89¾ x 144 in.)
Musée National d'Art
Moderne, Centre
Georges Pompidou, Paris

Rosenquist supported himself as a billboard painter and, like Warhol, he occasionally designed window displays for the department store Bonwit Teller in New York.

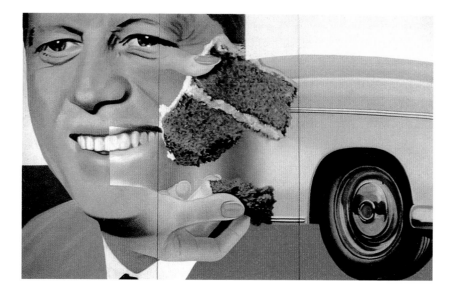

feet in front of our mind and our senses is attacked by radio and television and visual communications, through things larger than life, the impact of things thrown at us, at such a speed and with such a force that painting and the attitudes toward painting and communication through doing a painting now seem very old-fashioned.

In *President Elect*, the cake and car seem to have little to do with the President of the United States. As the artist later explained: 'the face was from Kennedy's campaign poster. I was very interested in people who advertised themselves. So that was his face. And his promise was half a Chevrolet and a piece of stale cake.' The disparate elements of which Rosenquist speaks take on a different, and more clearly political, connotation. Promises of plenty and good, they are held up as part of the President's campaign ushering in a new era of optimism.

A HERO IN A GESTURE

The Italian artist Sergio Lombardo systematically surveyed what he called the 'typical gestures' of political figures. According to Lombardo, one could immediately distinguish one politician from another through a raised hand or a pointed finger. Fascinated by the ways in which pre-eminent figures from Malcolm X to the Secretary

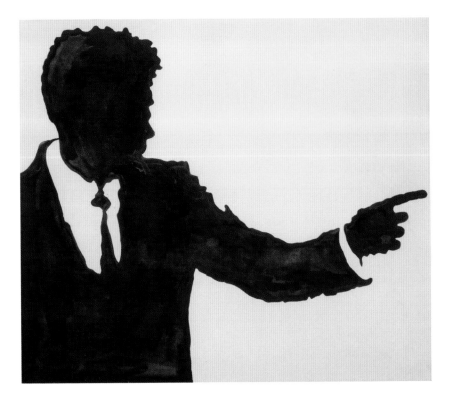

of the Soviet Party Nikita Khrushchev were presented in the media, the artist recalled: 'The great politicians were represented as omnipotent authorities through their elegant suits and peremptory gestures, they exercised power over a still naive audience.' John F. Kennedy, in the eponymous work from 1962 (above), is such a figure. Viewed in profile with his pointed finger, Kennedy is posing for both the audience and the media. Lombardo shows JFK as both American President and media icon.

Fascinated by the televised image of JFK, Robert Rauschenberg embedded many images of the President into his silkscreened canvases. Like Warhol, Rauschenberg turned to the silkscreen technique as a means of mechanically transferring images onto canvas. Characterized by a medley of photographic material, from the President to the Sistine Chapel, Rauschenberg's silkscreens drew attention to the fast-spreading image culture and visual deluge of modern life. In *Retroactive II* (1963; opposite), for instance, Kennedy is paired with an astronaut parachuting into space and a detail from Peter Paul Rubens's *Venus at a Mirror* (c.1615).

Sergio Lombardo
John F. Kennedy, 1962
Enamel paint on canvas,
170 x 200 cm (67 x 79 in.)
Private collection

This aesthetic is inspired by black-and-white press and television images.

Robert Rauschenberg
Retroactive 11, 1963
Oil, silkscreen and ink
on canvas, 203.2 x
152.4 cm (80 x 60 in.)
Museum of
Contemporary Art,
Chicago

Rauschenberg's use of disparate fragments reflects contemporary image saturation.

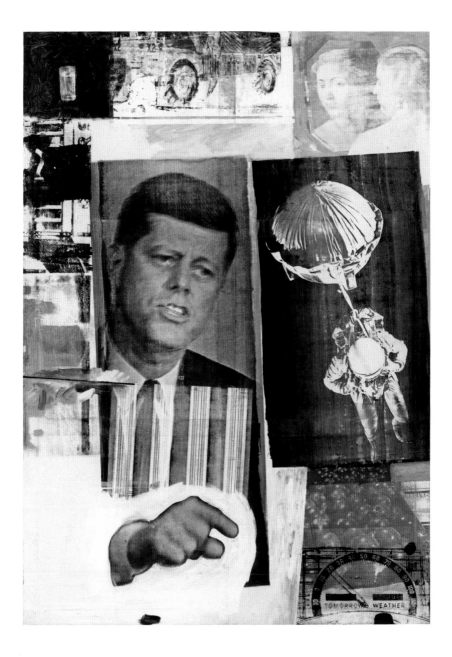

A SHOCKING BULLET

Switching to a more dramatic tone, Gerald Laing, in *Lincoln Convertible* (1964; below), captures the moment of JFK's assassination. Television brought live to people's homes the tragic unmaking of the 'Kennedy years' of optimism. On 22 November 1963 the President was fatally shot during an official visit to Dallas.

Rather than focusing on the gruesome scene, Laing turns to the site of the murder, the Lincoln convertible. The presidential motorcade extends here beyond the limits of the green canvas. A series of boldly screenprinted Benday dots (of the kind redeployed by Lichtenstein) signal the presence of the President, First Lady and other characters on board. The car, however, is the only element of the painting that is properly in focus, as everything else is presented as a blurry memory.

Recalling the making of *Lincoln Convertible* and the symbolical importance of the event itself, Laing stated:

That November the shiny image of America cracked from side to side. I heard the news in my studio on Fournier Street, when radio broadcasts were interrupted to announce the events in Dallas. . . . In spite of the ghastly violence of the twentieth century we had been endowed with a sanitized version of the past, which produced in us a sense of stability, which was as deeply held as it was false. Thus, when the President of the

Gerald Laing
Lincoln Convertible, 1964
Oil on canvas, 185.4 ×
281.9 cm (73 × 111 in.)
Private collection

**Laing made use of
shaped canvases, such as
this one, to convert his
paintings into objects.**

richest and most powerful country in the world proved to be
vulnerable to the assassin's bullet, it came as a terrible and
fundamental shock, which forced us all to adopt more realistic
attitudes towards the world about us.

Signalling a tidal change, JFK's death became a metaphor for
the world's vulnerabilities, which became more apparent with the
escalating death toll of the Vietnam War.

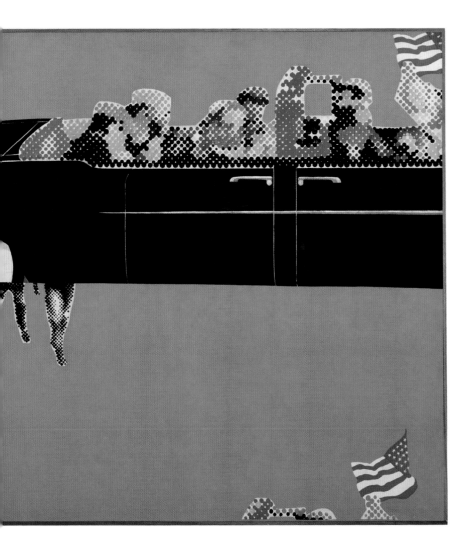

JACKIE ON REPEAT MODE

Warhol also captured the vulnerabilities to which JFK's assassination had exposed the world by turning to the President's private sphere – specifically to his wife the First Lady Jacqueline Kennedy, more commonly known as Jackie. As the other half of America's golden couple, Jackie had considerably contributed to JFK's success and popularity. In the wake of her husband's death, she quickly became the subject of media scrutiny.

An emblem of glamour, Jackie is replaced by her mourning self in the middle rows

Warhol, keen as ever to scrutinize the fusion of death and stardom, cast the famed First Lady as one of his most celebrated Pop icons. In *Sixteen Jackies* (1964; opposite), the image of Jackie is repeated sixteen times. Divided into four rows with each depicting a different image, Jackie is portrayed before and after the assassination. In the top and lowest rows she smiles, exuding confidence and optimism. An emblem of glamour, Jackie is replaced by her mourning self in the middle rows. A woman grieving the loss of her husband becomes a stand in for a national tragedy. Not just any man, it is the President of the United States whom she is mourning, and Warhol endeavours to exalt this aspect in his *Sixteen Jackies*.

PLAY MONOPOLY

While so far the focus has been on iconic political figures and newsworthy events, through the work of Swedish artist Öyvind Fahlström we turn our attention to Cold War geopolitics. The unrelenting tensions between the Eastern Bloc (Soviet Union and satellite states) and the Western Bloc (US and NATO allies) were characteristic of the post-war era. Ideologically and politically opposed, the two blocs attempted to rival each other on every possible front, from nuclear power to space travel.

By adapting the popular board game Monopoly, Fahlström envisioned the Cold War schism being played out through 'the game of capitalism'. Monopoly's real estate world was replaced in Fahlström's *World Politics Monopoly* (1970; pages 58–9) by the contested realm of the Cold War, with two corners of the board game commandeered by the United States and the other two by

Opposite: Andy Warhol
Sixteen Jackies, 1964
Acrylic and enamel on canvas, 204.3 x 163.6 cm (80⅜ x 64⅜ in.)
Walker Art Center, Minneapolis

Fame is irrevocably intertwined with a public display of grief.

**Overleaf:
Öyvind Fahlström**
World Politics Monopoly, 1970
Variable painting, 92 x 128 cm (36¼ x 50⅓ in.)
Private collection

Through his interactive works or 'painting games', Fahlström demanded the intervention of the viewer.

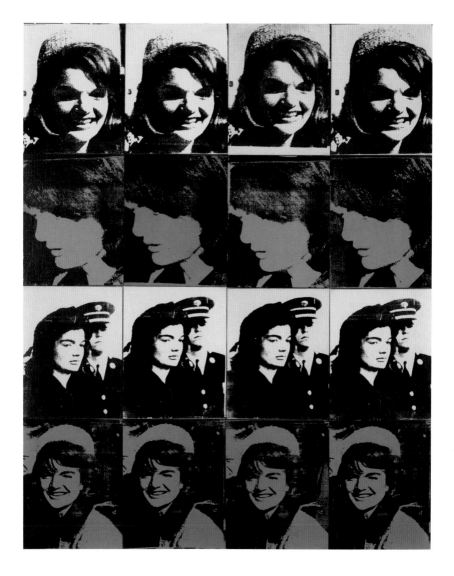

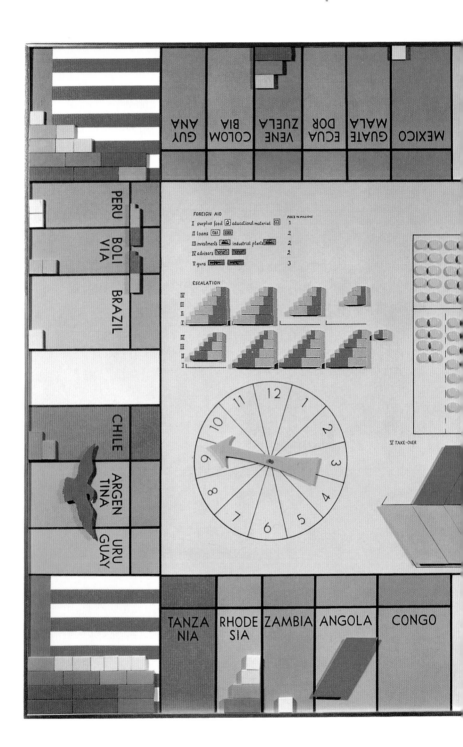

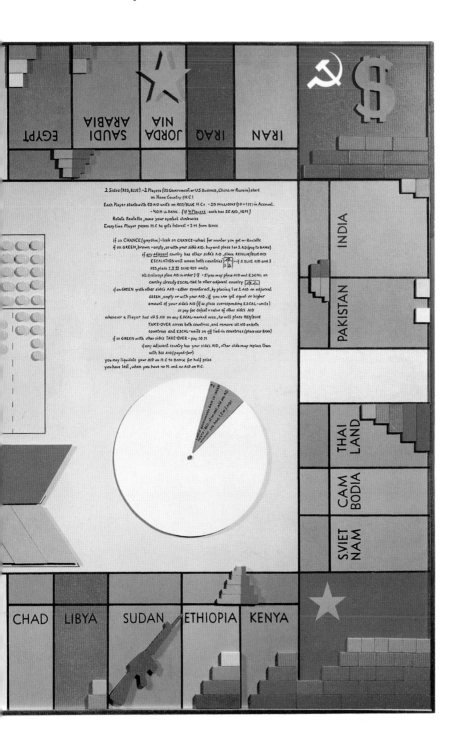

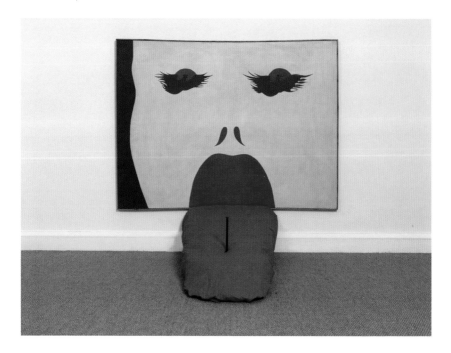

the Soviet Union and the People's Republic of China, respectively. *World Politics Monopoly* calls for the viewer's active participation in redefining the Cold War. As Fahlström declared:

> The role of the spectator as a performer of the picture-game will become meaningful as soon as these works can be multiplied into a large number of replicas, so that anyone interested can have a picture machine in his home and 'manipulate the world' according to either his or my choices.

Following the logic of mass circulation on which much of Pop Art's imagery was based, Fahlström aspired to make world politics accessible to everyone through his customized board game.

EASTERN EUROPEAN WINDS OF REBELLION
'Sweet bliss prevails. Nobody wants to make a fool of themselves, everybody is very serious, sombre, dead. Life has flown away somewhere . . .' An extract from Jerzy Ryszard 'Jurry' Zieliński and Jan 'Dobson' Dobkowski's manifesto 'Neo-Neo-Neo: Here We Come' sets the tone for the subversive nature of their pictorial

Jerzy Ryszard 'Jurry' Zieliński
Without Rebellion, 1970
Oil paint on canvas with pillow, fabric and nail, approx. 150 x 200 x 4 cm (45 x 80 x 1⅝ in.)
Private collection

Zieliński's works mimicked the flat and simplified aesthetic of contemporary posters, drawing on eastern Europe's strong tradition of graphic posters.

production. Zieliński, one of a number of eastern European artists showing an interest in Pop Art, is particularly remarkable. Running against Socialist Realism, the Soviet Union's approved form of art, Zieliński's turn to a Pop aesthetic was a courageous move.

The red flaming tongue is pierced with a nail securing it to the floor – a symbol for forced censorship

Without Rebellion (1970; opposite) was an act of defiance lucidly demonstrating Zieliński's yearning for freedom in his art and in his life. He portrays a simplified human face with eyes closed and a tongue extending beyond the painting into the viewer's space. On close inspection, the portrait shows Zieliński's concerns with freedom and rebellion. The eyes, for instance, are replaced by two Polish eagles set against a red sun, a symbol of Poland's foundation, turned green on this occasion to accentuate the negative connotations of the scene. Similarly the red flaming tongue, made from a soft cushion affixed to the canvas, is pierced with a nail securing it to the floor – a symbol for forced censorship. Zieliński's work is clearly political, addressing the complex circumstances of Cold War Poland. Unlike many of the works discussed in this chapter that only comment on politics, Zieliński's *Without Rebellion* is a political instrument, propelling political action.

KEY WORDS

History painting, politics, Cold War, Monopoly, censorship, protest, political leaders, Eastern Bloc, Western Bloc, printed news, civil rights movement, guerrilla pancakes, May 1968, call to arms, yearning for freedom, television

KEY FIGURES

John Fitzgerald Kennedy, Jacqueline Kennedy, Malcolm X, Karl Marx, Mao Zedong, Sigmund Freud, Che Guevara

KEY ARTISTS

Öyvind Fahlström, Jerzy Ryszard 'Jurry' Zieliński, James Rosenquist, Sergio Lombardo, Robert Rauschenberg, Gerald Laing, Andy Warhol, Claudio Tozzi, Joe Tilson, Joe Overstreet

Profile
of the
Viet
Cong

APRIL 12, 1965 35c

I am the hounded slave, I wince at the bite of dogs. Hell and despair are upon me, crack again and crack the marksman, I clutch the rails of the fence, my gore dribs, thinn'd with the ooze of my skin. I fall on the weeds and stones. The riders spur their unwilling horses, haul close, Taunt my dizzy ears and beat me violently over the head with whip-stocks.

Agonies are one of my changes of garments.

I do not ask the wounded person

LIFE

DEEPER INTO
THE VIETNAM WAR

POP AT WAR

-

The great initiative in this war is ours.
The initiative to stop it must be ours

-

Martin Luther King, Jr

1967

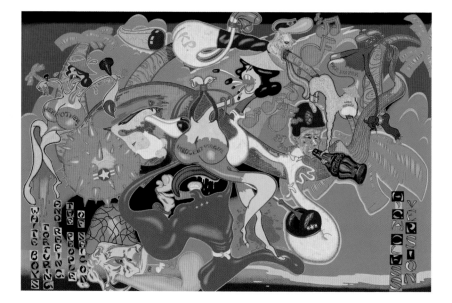

While the memory of the Second World War was still fresh in people's mind, nuclear war emerged as a constant threat. Likewise, the Vietnam War was a reality witnessed by many across the globe through television. Conflicts, especially that in Vietnam, were made part of the everyday and war, with all its different facets, became one of Pop Art's most frequent motifs. This included the many anti-war movements that sprung up as a consequence of the brutalities and the rising number of fatalities produced by the Indochinese conflict.

The Vietnam War, which set out to unify North and South Vietnam, became embroiled in the Cold War tensions and America's fight against Communism. Allied with the USSR and China, North Vietnam espoused Communist ideology, while South Vietnam was allied with America. The Vietnam War, which started in 1955, intensified during the 1960s, a period in which the American government increased its support of South Vietnam by sending increasing numbers of young men to the front. Countless people were killed during this brutal conflict, including American soldiers, Vietnamese civilians and members of the Viet Cong, a Communist guerrilla force from North Vietnam. Images of what many perceived as a senseless war filled the media across the world, leaking the atrocities experienced by Vietnamese civilians at the hands of American troops, while also showing the distressing loss of thousands of young American soldiers. A war producing millions of casualties, the Vietnam War was visually confronted by American and foreign artists alike. Maintaining for the most part an anti-war stance, they all took the shocking images released by the media as a starting point for their works.

Peter Saul
Saigon, 1967
Acrylic, oil, enamel and fibre-tipped pen on canvas, 236.9 x 361.3 cm (93¼ x 142¼ in.)
Whitney Museum of American Art, New York

The bright hues of Saul's painting are in stark contrast with the ominous subject matter.

STRUCK BY SAIGON

The American artist Peter Saul was inspired by popular culture but relied on a style that treaded the line between Expressionism and Surrealism. In his *Saigon* (1967; opposite), one of a series of anti-Vietnam paintings, he addressed the brutalities perpetrated by American soldiers on Vietnamese soil. The bright colours and the stylized caricatures dominating this painting suggest a rather gleeful and uplifting scene. This feeling is overturned when, on closer inspection, it becomes plain that violence is the true subject. Entitled *Saigon*, the capital of South Vietnam, this painting immediately points the viewer to the geography of Vietnam and its gruelling war. The site of tragedy and disaster, Saul's war-torn Saigon (now Ho Chi Minh City) takes, as its primary subject, a

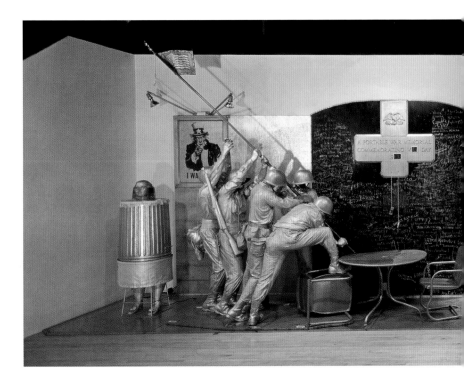

young Vietnamese girl carrying the label of 'Innocent Virgin'. Her family is being tortured and dismembered by American soldiers drinking Coca-Cola. Synonymous with American imperialism, Coca-Cola frequently appeared in Pop artworks commenting on the export of American goods, ideals and lifestyle abroad. Here the innocent drink is treated as a stand in for America's unreasonable violence towards Vietnamese civilians, whose body parts are scattered across the painting's surface. Enhancing the image's graphic violence, Saul's overt condemnation of the war is spelled out in the lower corner of the canvas, where in Oriental characters, he denounces: 'White Boys Torturing and Raping the People of Saigon: High Class Version.'

PORTABLE WAR MEMORIAL

Like Saul, fellow American artist Edward Kienholz maintained a very critical stance towards the Vietnam War, which he expressed through his *The Portable War Memorial* (1968; above). It is only ironically portable as the work is monumental in scale. A reconstruction of what reads as a suburban snack bar, complete

Edward Kienholz
The Portable War Memorial, 1968
Plaster casts, tombstone, blackboard, flag, poster, photographs, working Coca-Cola machine, stuffed dog, wood, metal and fibreglass, 285 x 950 x 240 cm (112.2 x 374 x 94.5 in.)
Museum Ludwig, Cologne

Kienholz stressed the bleakness of war by expunging all colour from his memorial and casting a grey mist over the scene.

with tables and chairs, a hot dog stand and a Coca-Cola machine, Kienholz's sculptural installation is a denunciation of war and the ways in which it seamlessly infiltrates the everyday.

Kienholz extends his invective against all wars: past, present and future

A brutal phenomenon whose toll on human lives is enormous, the war here is combined with the banality of suburban life, carrying on as normal regardless of the inhumanities perpetrated abroad. Although made during the Vietnam War, Kienholz extends his invective against all wars: past, present and future. A recruitment poster from the First World War, behind the group of soldiers who proudly raise the American flag at the Battle of Iwo Jima, enhances the memorial's fluidity across epochs and wars. The panel behind the table and chairs has been left blank by the artist to be filled by the viewer with details of varying conflicts. Ultimately this haunting work reminds us that war is always destructive and never beneficial.

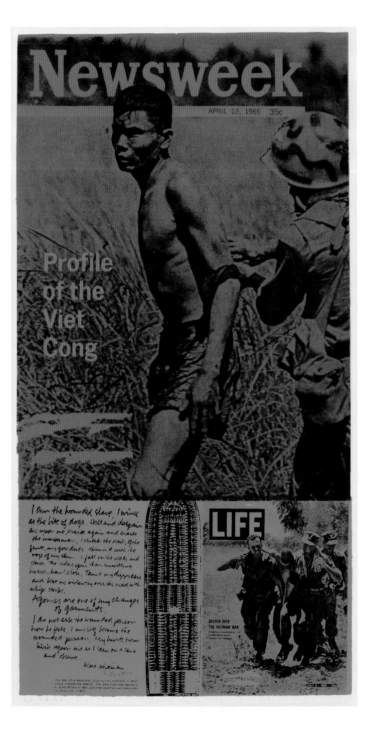

Corita Kent
news of the week, 1969,
from the series *Heroes
and Sheroe*s
Silkscreen print, 58.5 x
30.6 cm (23 x 12 in.)
Corita Art Center,
Immaculate Heart
Community, Los Angeles

**Corita extracted the
source material from
the leading magazines
of the time, including
Newsweek, *Life* and
Time. A bold but direct
commentary on current
events, this and other
works from her series
shows up Corita's
activist spirit.**

THE NUN: GOING MODERN

Sister Corita's contribution to Pop Art came as a surprise to many. Described by the popular *Newsweek* magazine as 'The Nun: Going Modern' in 1967, the Catholic nun Corita Kent (née Frances Elizabeth Kent) joined the Order of the Immaculate Heart of Mary as a teenager. She received a master's degree in Art History from the University of Southern California and then went on to become a practising artist. Working across media she experimented with painting, photography and graphic design. Most of her energies, however, were devoted to silkscreen-printing. It was through screen-printing that Sister Corita made a name for herself and brought unexpected attention to the art department of the Immaculate Heart where she taught.

'Sister Corita did for bread and wine what Andy Warhol did for tomato soup'

In light of the tumultuous events that were shaking the world in the 1960s, from civil rights to anti-Vietnam War movements, as well as feminist struggles, Corita felt compelled to voice her anguish through silkscreen-printing. Combining found images taken from the media with her own psychedelic typographic style, Corita produced many prints that, thanks to low production costs, could be purchased inexpensively from the community centres and fairs where she sold them. Fascinated by the surge in advertising and urban signage, Corita took many of her mottos from famous adverts, including ones for Pepsi and Coca-Cola. She stated:

The sign language is almost infinitely rich . . . Up and down the highways (good symbols too) we see words like 'Cold, clear, well-water,' 'The best to you each morning,' 'Have a happy day,' 'Sunkist,' 'Del Monte's catsup makes meatballs sing,' that read almost like translations of the psalms for us to be singing on our way. The game is endless, which makes it a good symbol of eternity which will be a great endless game.

Merging the sacred with the mundane, Corita endeavoured to build a bridge between advertising and religious scripture. As the *New York Times* pertinently highlighted: 'Sister Corita . . . did for bread and wine what Andy Warhol did for tomato soup.' Increasingly turning her attention to contemporary political events, *news of*

the week (1969; page 68) juxtaposes fluorescent green and red hues with revealing images of the Vietnam War brought home by *Newsweek* and *Life*. Eventually Corita's educational stance and activism proved too radical for the Immaculate Heart of Mary and she left the order in 1969 after Cardinal John McIntyre accused her of being 'a guerrilla with a paint brush'.

MISS AMERICA

The German artist Wolf Vostell and the French artist Bernard Rancillac both sought to raise awareness of the Vietnam War by linking it with beauty models. Apparently far-fetched, and perhaps inappropriate too, the connection with beauty was utilized to undermine the indifference developed by many towards this bloody conflict. Setting out to paint one painting for every day of the year 1966, Rancillac took his images from newspapers. The latest news was instantly transformed into painting with no historical distancing in between. Although the initial goal was to produce 365 paintings, Rancillac fell short of his original target. Nevertheless *At Last a Silhouette Fitted to the Waist* (1966; opposite) represents the ambitions of the project well.

The self-indulgence of the west is too concerned with appearances to be moved by the realities of the Vietnam War

Devised so that it can be exhibited hanging from both the top or the bottom, *At Last a Silhouette Fitted to the Waist* combines two starkly diverging images. On the one hand, a female model lifted from an advertisement for female underwear poses showing off the product's comfort and adaptability. On the other hand, a gruesome scene is unfolding as a group of American soldiers torture Vietnamese prisoners by forcing their faces into a hot boiling cauldron. The contrast between the two images could not be greater, and this is exactly Rancillac's intention. Through the image's irreconcilability, the artist aims to reveal the self-indulgence of the west – too concerned with appearances to be moved by the realities of the Vietnam War.

Closely aligned with Rancillac is Vostell's *Miss America* (1968; page 72). Addressing a similar set of concerns, Vostell's silkscreen print juxtaposes a gleeful model with a South Vietnamese general executing a Viet Cong prisoner. Leaping forwards and upwards,

Bernard Rancillac
At Last a Silhouette Fitted to the Waist, 1966
Vinyl paint on canvas, 195 x 130 cm (76¾ x 51¼ in.)
Musée de Grenoble, Grenoble

Rancillac's ambitious series of paintings from 1966 included works addressing contemporary themes, such as the introduction and legalization of the contraceptive pill.

1 • la haute dasale élas-
tique amincit la taille encor-
re mieux qu'on combiné
et beaucoup plus confor-
tablement.

2 • les côtés et le dos en
élastique aéré effacent les
bourrelets en douceur.
l'inix vos hustiers ou vos
combinés qui compriment
toute la journée.

3 • la coupe des bonnets
met en valeur la poitrine
grâce à sa parfaite adap-
tation: 11 tailles, 3 profon-
deurs de bonnets à b e
sans armature.

4 • le décolleté croisé
élastique sépare élégam-
ment la poitrine main-
tient fermement.

5 • les bretelles élastiqu
ues réglables ne roulent
plus et gardent leur éla-
sticité même après de
nombreux lavages.

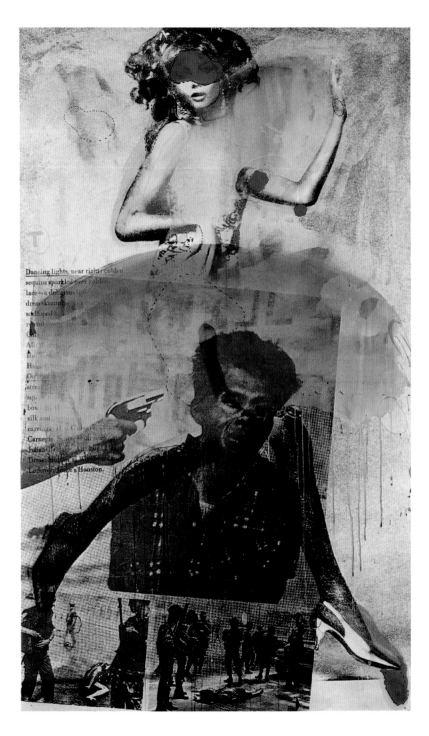

Wolf Vostell
Miss America, 1968
Screen photography,
transparent paint and
silkscreen on canvas, 200
x 120 cm (78¾ x 47¼ in.)
Museum Ludwig, Cologne

**From the early 1960s
Vostell subjected
photographs found
in magazines and
newspapers to
brutal over-painting,
to highlight the
violent nature of the
subject matter.**

the model is out of place amid the Vietnamese conflict. Her face covered in a red drop, symbolizing blood, is a nod to the ferocity of the conflict that was nowhere near resolved at that point. Vostell selected one of the Vietnam War's most recognizable photographs: an Associated Press Pulitzer Prize-winning photograph by Eddie Adams. Memorable for its barbaric contents, Adams's photograph also contrasts with the triviality of the fashion model – one of hundreds – ready to be replaced the following season by a new and equally gleeful beauty queen.

NUCLEAR APOCALYPSE

At end of the Second World War, America had dropped nuclear bombs on Hiroshima and Nagasaki in Japan. This event marked the beginning of the threat of a nuclear apocalypse that pervaded the post-war years. After the war, the Soviet Union caught up with its Cold War rivals by increasing its nuclear capabilities through missiles and bomber planes. Both sides were caught up in the arms race, a central feature of the Cold War. Fearful of another attack on the scale of Hiroshima and Nagasaki, but also conscious of the side effects triggered by nuclear tests, anti-nuclear movements made their voices heard through rallies and marches. Particularly strong was the Campaign for Nuclear Disarmament (CND) founded by British activists. Pop artists David Hockney and Richard Hamilton were included among its most vocal members.

-

**Models are made protagonists of this absurdist collision
of fashion and war**

-

Unlike his peers, Colin Self did not take part in CND marches, but voiced his anxieties in a number of works from the 1960s. For instance, Self showed his growing concern with the possibility of nuclear warfare in his iconic painting *Two Waiting Women and B52 Nuclear Bomber* (1963). As the Cuban Missile Crisis between the Soviet Union and the United States had demonstrated in 1962, nuclear armament was a persistent threat throughout the Cold War years. In Self's painting, a B52 bomber enters the frame of a fashion shoot. Models, as in Vostell's and Rancillac's critical renderings of the Vietnam War, are made protagonists of this absurdist collision of fashion and war. Untouched by the ominous presence of the B52 bomber carrying nuclear armaments, the models maintain their

poses as if the nuclear threat has not only left them untouched but is also inconsequential to the realm of glossy magazines for which they model.

A NEW CRUCIFIXION

The reinterpretation of Christ's Crucifixion was a bold and very controversial move on the part of the Argentinian artist León Ferrari. As an artist Ferrari is more strictly conceptual than Pop. However, with *The Western, Christian Civilization* (1965; opposite), he contributed a significant chapter to the history of Latin American art generally and Pop specifically. By replacing Christ's familiar cross with a US bomber, Ferrari critically raised awareness of Argentina's 'promiscuous' involvement with America. At the same time, the overtly blasphemous use of such a sacred image was meant to question Christianity and its values, considered by Ferrari to be at the root of many contemporary evils. Using the US bomber to allude to America's participation in the Vietnam War, the artist offered a crude commentary on contemporary global perils, which neither allowed space for redemption nor held the promise for eternal life as traditionally symbolized by Christ's Crucifixion. A bleak commentary on the present, Ferrari's *The Western, Christian Civilization* has increasingly gained iconic recognition.

León Ferrari
The Western, Christian Civilization, 1965
Mixed media, 200 x 120 x 60 cm (78¾ x 47¼ x 23⅝ in.)
Fundación Augusto y León Ferrari Arte y Acervo (FALFAA), Buenos Aires

Ferrari put this work forward for the Instituto Torcuato Di Tella prize of 1965. It was met with resistance by the authorities who eventually censored it by removing it from the competition.

KEY WORDS

War, Vietnam War, anti-war movements, war monuments, nuclear threat, B52 nuclear bomber, religion, subversion, Viet Cong, fashion models, beauty queens, *Newsweek*, *Life*, *Time*

KEY ARTISTS

Peter Saul, Edward Kienholz, Sister Corita, Bernard Rancillac, Wolf Vostell, Colin Self, León Ferrari

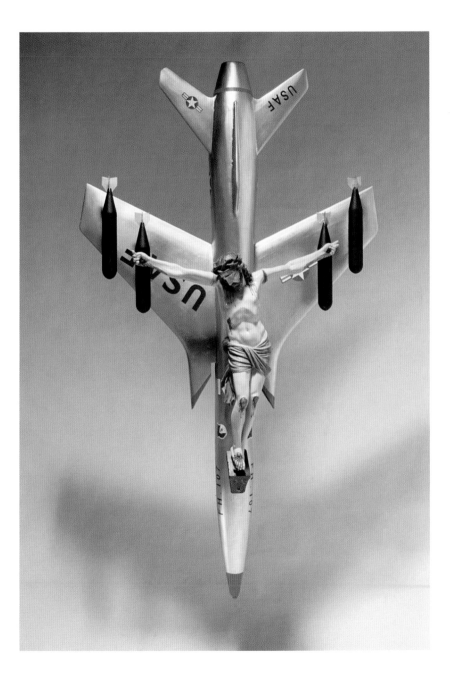

POP GOODS

-

Stifled by this rarefied atmosphere,
some young painters turn back to some less
exalted things like Coca-Cola, ice-cream sodas,
big hamburgers, super-markets and 'EAT' signs.
They are eye-hungry; they pop . . .

-

Robert Indiana

1963

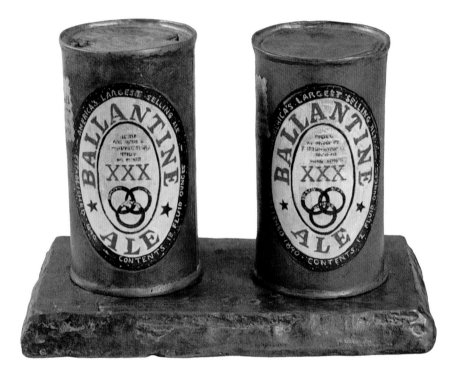

Opposite:
Jasper Johns
Painted Bronze /
Ale Cans, 1960
Oil on bronze, 14 x 20.3 x
12 cm (5½ x 8 x 5 in.)
Museum Ludwig, Cologne

**Painted Bronze / Ale
Cans** belongs to a series
of small sculptures cast
in bronze, which also
includes replicas of light
bulbs and flashlights.

Goods of every kind, from slices of cake to discarded toys,
entered Pop Art's repertoire of motifs. Commenting on the
impact of alluring packaging and the marketing strategies behind
their promotion, Pop artists drew attention to the sinister side of
consumption as well as to its wide appeal. Jasper Johns pioneered
the use of off-the-shelf commodities as a subject for an artwork
with his *Painted Bronze / Ale Cans* (1960; opposite), a faithful
reproduction in bronze of Ballantine ale cans. The work owes its
genesis to Johns' response to older artist Willem de Kooning's tirade
against him. Complaining about Johns and his powerful dealer Leo
Castelli, de Kooning declared 'that son-of-a bitch [Castelli] you
could give him two beer cans and he could sell them'. Inspired by
this, Johns made two bronze replicas of beer cans and as Johns said,
of course, 'Leo sold them'. Beside the rivalry between the falling
Abstract Expressionists of which de Kooning was an exponent
and the rising Pop artists to whom Johns was seen to belong,
this episode points to the growing allure of commercial goods.

Speaking of Coca-Cola, an oft-used good in the Pop world to
refer to consumption, Warhol authoritatively asserted:

> What's great about this country is that America started the
> tradition where the richest consumers buy essentially the same
> things as the poorest. You can be watching TV and see Coca-
> Cola, and you can know that the President drinks Coke, Liz
> Taylor drinks Coke, and just think, you can drink Coke, too.
> A Coke is a Coke and no amount of money can get you a better
> Coke than the one the bum on the corner is drinking. All the
> Cokes are the same and all the Cokes are good. Liz Taylor knows
> it, the President knows it, the bum knows it, and you know it.

Warhol's statement upholds Coke's democratic nature: the same
drink for all its customers regardless of gender, status and race.
Similarly, all the goods discussed in this chapter are banal to the
point of being barely noticeable, but are made to stand out through
the artists' alternatively admiring and scrutinizing depictions.

Overleaf:
Andy Warhol
*Campbell's Soup
Cans*, 1962
Synthetic polymer paint
on thirty-two canvases,
51 x 40.5 cm (20 x
16 in.) each
Museum of Modern Art
(MoMA), New York

**This artwork was first
displayed in the Ferus
Gallery in Los Angeles.
The gallery had been
founded by Pop artist
Edward Kienholz and
critic and curator Walter
Hopps in 1957.**

EVERY DAY FOR TWENTY YEARS

Quintessentially tied to Warhol's iconography is the Campbell's
soup can. A product present in every American household and
supermarket, like Coca-Cola, it levelled its buyers. Ascribing his
interest in Campbell's soup to routine, Warhol recalled: 'I used to
drink it. I used to have the same lunch every day, for twenty years,

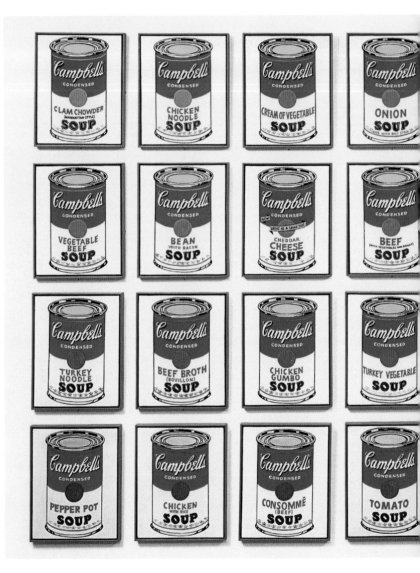

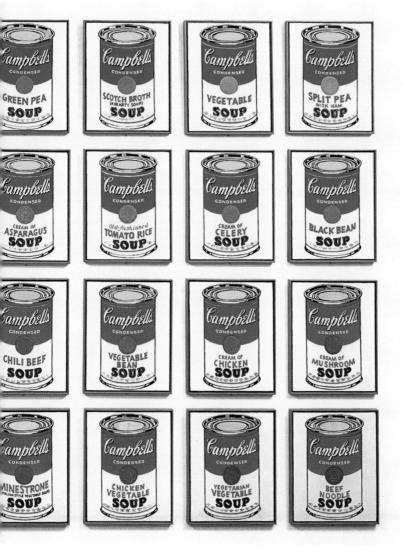

I guess, the same thing over and over again.' Sounding like an addiction, Warhol's repetitive lunches consisting of Campbell's soup day in and day out for twenty years match the many repetitions to which the artist subjected the soup can itself. *Campbell's Soup Cans* (1962; pages 80–81) was the first in this long lineage of two-dimensional painted replicas of the red-and-white can.

Originally conceived as thirty-two single pieces, *Campbell's Soup Cans* was first exhibited at the Ferus Gallery in Los Angeles. This public showing of literally off-the-shelf supermarket products was met at best with mystification and at worst with outright hostility. Such was the mockery that a neighbouring gallery placed a stack of real Campbell's soup cans in their shop window, selling three for 60 cents. Sales of Warhol's paintings were slow and the owner of the gallery eventually resolved to buy the *Campbell's Soup Cans* in bulk. Since then they have become an inseparable unit in the collection of the Museum of Modern Art in New York.

COCA-COLONIZATION

Coca-cola, as Warhol's words suggested, was a good within everybody's reach. Yet the humble Coke bottle was habitually chosen by artists across the glob as a symbol of present-day imperialism. Exported virtually everywhere, the ubiquitous red branding that accompanied the drink could not be avoided, leading Pop artists to question the importance of this dominant symbol. Synonymous with America and its value system, Coca-Cola was incorporated into the works of Warhol (who repeatedly turned to the famed bottle), Marisol and Wesselmann, among others.

Rauschenberg, often considered one of the forerunners of Pop Art, in his *Coca-Cola Plan* (1958; opposite, above) celebrated Coca-Cola as an American cultural and social icon. The triumphal role ascribed to Coca-Cola as a good and an export is symbolized by the wings suspended on both sides of the work. Recalling *The Winged Victory of Samothrace* (c.200–190 BCE), one of the Louvre's most treasured masterpieces, the wings attached to Rauschenberg's modern emblem ironically hint at the historic sculpture.

While Rauschenberg celebrated Coca-Cola and by extension America with his *Coca-Cola Plan*, the Japanese artist Ushio Shinohara undermined both with his spoof *Coca-Cola Plan* (1964; opposite, below). Shinohara first came across American Pop Art in the magazine *Art International* in January 1963. This fortuitous encounter led him to create what he referred to as 'Imitation Art': replicas of existing Pop artworks, meant as parodies of the famed

Robert Rauschenberg
Coca-Cola Plan, 1958
Pencil on paper, oil on three Coca-Cola bottles, wood newel cap, and cast metal wings on wood structure, 68 x 66 x 13.7 cm (26¾ x 26 x 5⅜ in.) The Panza Collection, Museum of Contemporary Art, Los Angeles

In the upper section of the work, a diagram schematically outlines the construction of *Coca-Cola Plan*. It suggests that the planning is not for the artist alone but also for the viewer to assess.

Ushio Shinohara
Coca-Cola Plan, 1964
Fluorescent paint, three Coca-Cola bottles, pegs, nails and plaster wings on wood structure, 71.5 x 65.5 x 6.5 cm (28⅛ x 25¾ x 2½ in.) Museum of Modern Art, Toyama

Shinohara met Rauschenberg and showed him his *Imitation Art* series in 1964.

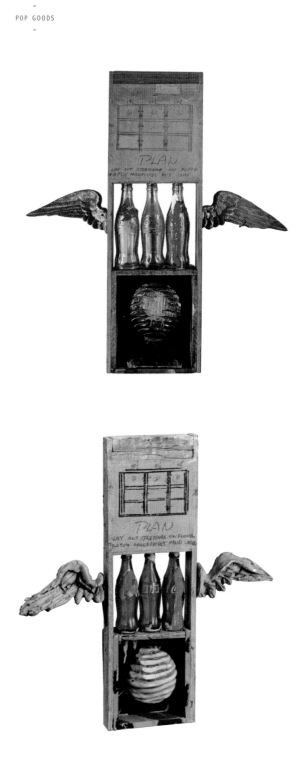

originals, which were first exhibited at Naiqua Gallery in Tokyo in September 1963. As part of this series, Shinohara created multiple replicas of Rauschenberg's *Coca-Cola Plan*. The aim was not only to debunk American Pop Art but also to do so on Pop Art's own terms. Pop artists and their works lent themselves to endless replication, Shinohara told us, especially those that advocated multiplication and replication (primarily works by Warhol). By exploiting Pop Art's use of commercial goods like Coca-Cola, Shinohara was able to destabilize the originality of Rauschenberg's work and of Pop more broadly. In other words, he imitated an art that was already imitative by default due to its subject matter. Coca-Cola no longer carried America's triumphal flag: it was made expendable and endlessly replicable.

Christa Dichgans
Weihnachten – New York, 1967
Acrylic on canvas in wood frame, 140 x 100.3 cm (55 x 39½ in.)
Contemporary Fine Arts, Berlin

Through these valueless goods Dichgans comments on the fast expendability to which objects are subjected in a mass-consumerist society.

Discarded toys have lost both their commercial and sentimental allure

TOY STORY

Turning to material rather than edible goods, the German artist Christa Dichgans showed a fascination for toys, as visualized in *Weihnachten – New York* (1967; opposite). Having moved to New York in the early 1960s, Dichgans admired the 'mountains of discarded toys' that could be found in Salvation Army charity shops. As a mother of a young son, she also had first-hand experience of toys left randomly in a pile. In *Weinachten – New York* (one of a series of paintings around this theme), she referenced the Christmas craze around toys, but rather than featuring brand new toys ready to be unpacked, she presented the viewer with a pile of discarded teddy bears, dolls and rocking horses. Once upon a time these would have been cherished toys, but now they have lost both their commercial and sentimental allure.

Like Dichgans, Erró (Gudmunder Gudmundsoon) is critical of consumer habits associated with the American lifestyle, symbolized by plentifully stocked supermarkets. Of Icelandic origins, Erró settled in Paris in the late 1950s and soon entered into a dialogue with fellow French artists interested in the revival of figuration as a means to confront the everyday and consumer society especially. *Foodscape* (1964; page 86), with its overwhelming amount of goods tightly packed across the surface of the canvas, denounced the compulsion to acquire packaged goods engendered by American

consumerism. From lavish cheese platters to Nestlé bars and sliced cakes, everything is on offer in this sea of food.

Implicitly addressing the consumer logic that sees customers no longer buying out of necessity, but lured instead by advertising and its far-reaching persuasive powers, *Foodscape* and the almost-contemporary *Special K* (1961; opposite) by Derek Boshier point to the increasing dominance of America's economic and political power. Appropriating the iconic red K from the Kellogg's cereal brand, Boshier combines it with a flaming rocket entering the K from the bottom of the painting. Alluding to the space race in which America and the Soviet Union competed for the control of space (see pages 140–51), the K is turned here into an emblem of coercive power aimed at conquering earthly goods as much as extra-terrestrial ones. As Richard Smith, an early commentator on Boshier's work, affirmed:

> Some of these themes are recurring like Americanization. Stars and stripes eat into an 'England's Glory' matchbox, or a Cuban flag; the Union Jack is cornered by two Pepsi-Cola bottle tops. Whether this Americanization is welcomed, deplored or just accepted is left in the air. Also in the air are the space subjects he tackles. The interest is not, it appears, to glorify modern technology. The fact that there is a space race is shown some

Erró
Foodscape, 1964
Oil on canvas, 201 x
301 cm (79 x 118½ in.)
Moderna Museet,
Stockholm

**This work is based on
a collage of images
culled by Erró from
the mass media.**

concern: the space heroes are important but other heroes get
equal billing in the cosmos.

LIKE A PASTRY COOK

Oldenburg opened his eponymous store on 1 December 1961 at
107 East 2nd Street in New York. Setting out the parameters of this
endeavour in what reads either as a manifesto or more mundanely as
a user manual, Oldenburg stated:

> The Store, or My Store, or the Ray-Gun Mfg. Co., located
> at 107 E. 2nd St. NYC is eighty feet long and varies about
> 10 ft. wide. In the front half, it is my intention to create the
> environment of a store, by painting and placing (hanging,
> projecting, lying) objects after the spirit and in the form of
> popular objects of merchandise, such as may be seen in stores
> and store windows of the city, especially in the area where the
> store is.
>
> This store will be constantly supplied with new objects which
> I will create out of plaster and other materials in the rear half of
> the place. The objects will be for sale in the store . . . The store
> may be thought of as a season-long exhibit.

Derek Boshier
Special K, 1961
Oil, collage and pencil on
canvas, 121.5 x 120.5 x
2.5 cm (48 x 47 x 1 in.)
Mayor Gallery, London

**Boshier explores the
impact of America and
its goods on post-war
British society.**

The Store soon turned out to be the centre of Oldenburg's activities. Not only a functioning shop, it also acted as a studio where the artist fabricated his make-believe products. Ranging from fake food platters to dresses and cake stands, Oldenburg's artworks intentionally treaded the line between banal everyday objects and precious works. Oldenburg's cakes retain a sculptural feel and a painterly touch that clearly positions them as artworks. Made out of canvas dipped in plaster, each 'product' was then painted with very loose brushstrokes that called to mind traditional still lifes and spoofed the gestural aesthetic of Abstract Expressionism.

Describing it as an anti-museum situation, Oldenburg made plain the subversive nature of The Store, which posed as a shop but ultimately read as a hybrid between a plagiarized store and a debunked museum. Products could be purchased there but prices were absurd. Bread, pastries, ham and other goods were more expensive than the original products, making naive buyers feel like they had purchased an artwork. Oldenburg's imitation of edible and widely commercialized food should be read against Erró's critical take on plentiful food in his *Foodscape*. Both artists turned to food as a way of highlighting and undermining consumer trends.

While Warhol enthusiastically embraced America's most popular packaged goods, as in his *Campbell's Soup Cans*, European artists such as Dichgans, Erró and Boshier critically incorporated objects and consumer products into their works. Claes Oldenburg's now iconic The Store occupied a middle ground between these two extremes.

Thiebaud sought a naturalistic record of enticing goods presented in all their beauty

CAKE, CAKE, CAKE

Wayne Thiebaud, an artist based in California, also turned to consumer goods, but he did so through the eyes of the happy consumer in *Cakes* (1963; opposite). Reviving the ordinariness of the still life and its subjects, Thiebaud, unlike his peers, sought a naturalistic record of enticing goods presented in all their beauty. At one remove from Oldenburg's coarse pastry, Thiebaud's cakes are seductive. Tempting the viewers' appetite through the thick impasto, Thiebaud mimics the luxurious consistency of cake. Speaking of his attraction to food as a subject matter the artist proclaimed:

Wayne Thiebaud
Cakes, 1963
Oil on canvas, 152.4 x 182.9 cm (60 x 72 in.)
National Gallery of Art, Washington, DC

The richly crafted and luxuriously textured cakes recall the feel, smell and consistency of freshly baked cakes decorated with icing and cream.

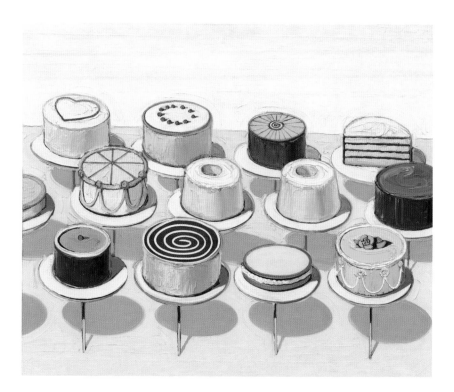

then there is another aspect of foodstuffs, one which interests me a great deal. Food as a ritualistic offering – that is – making food seem like it is something more than it is – dressing it up and making it very special. It has something to do with our preoccupation for wanting more than we have. Or a little more than we know.

Bringing his concerns back to consumption and the enticing strategies used by commercial artists to promote their products, Thiebaud highlights the ritualistic power ascribed to food. Cakes in particular, as he went on to confess, 'are glorious, they are like toys'. Enthused with a childlike excitement for food with a colour, texture and shape that was quintessentially American, Thiebaud went on to dedicate a number of paintings to hot dogs, sundaes and sandwiches, among others.

His survey of the American food offerings formed the bulk of his pictorial production between 1960 and 1962. In 1961 he carried a sample of these paintings to New York, where he showed them in an exhibition the following year. Praised for what appeared to

K. P. Brehmer
Pin-Up 25. The Feeling between Fingertips . . . from *Graphics of Capitalist Realism* portfolio, 1968
Screenprint and seed packets on folded paper board, 69.7 x 49.7 cm (22¼ x 31½ in.)
Walker Art Center, Minneapolis

A prolific printmaker, Brehmer sought to expand beyond the two-dimensionality of prints by including objects, such as the seed packets, in this work. The wording 'Das Gefühl zwischen Fingerkuppen' translates as 'The Feeling between the Fingertips'.

be a social criticism of food despite the lushness of the pictures, Thiebaud was quickly hailed as one of Pop's leading artists, thanks to his 'slice-of-cake-school'.

LIFE WITH POP

The German artists Gerhard Richter, Konrad Lueg and Sigmar Polke positioned themselves as the leaders of German Pop Art. They insisted that 'Pop Art was not an American invention, and we do not regard it as an import . . . This art is pursuing its own organic and autonomous growth in this country.' Like many artists working with a Pop lexicon outside America, the three German artists were compelled to assert their independence from their overbearing American peers. Nevertheless, Richter and Lueg's exhibition *Life with Pop: A Demonstration for Capitalist Realism* was partly indebted to Oldenburg's The Store.

Taking place in a furniture store in Düsseldorf, the artists made conceptual use of the extensive shop with its mocked-up bedrooms and living rooms. The core of the show consisted of Richter and Lueg dressed finely in suits and performing as part of the work. Seated respectively on a couch and an armchair, both raised on white plinths to endow the furniture pieces with a sculptural status, the two artists' living sculptural contribution was accompanied by a switched-on television set, broadcasting the news of West German Chancellor Konrad Adenauer's resignation. A critique once again of consumer habits, this time the display was engendered by the 'economic miracle' experienced by West Germany when Adenauer was at the helm. Richter and Lueg's subversion of the furniture shop's norms and procedures ended with the closure of the exhibition within two hours of its opening. Despite its short duration, this event was critical in signalling the emergence of Capitalist Realism, a manifestation of Pop Art in Germany underpinned by a clear social, economic and political mission.

René Block, who was dedicated to the promotion of this group of artists, opened a gallery in West Berlin in 1964. As part of the gallery's activities, Block promoted a series of prints and multiples by artists he represented. Among them was K. P. Brehmer, whose background in commercial printing was central to his satirical take on advertising strategies, as revealed by *Pin-Up 25. The Feeling between Fingertips* (opposite), included in the *Graphics of Capitalist Realism* portfolio of 1968. Here a sensually posed woman smoking a cigar, an unsubtle phallic reference, is juxtaposed with pre-packaged seeds of different types, such as onions and carrots. The bright

hues of the woman's unnatural looks match the fake look of the packaged seeds. Too orange and too green to be real, the carrots and courgettes are made to be carriers of the fake promise of homegrown vegetables and flowers. K. P. Brehmer seeks to expose the power and allure of advertising, which, as in many of the works discussed earlier, was a dominant trend.

Thomas Bayrle
Ajax, 1966
Oil on wooden
construction, electric
motor, 225 x 105 x 12 cm
(88½ x 41 x 5 in.)
Museum für Moderne
Kunst (MMK), Frankfurt

Bayrle's painting stood out as a reaction to the frenzy around cleanliness, which took over post-war Germany

Bayrle's apprenticeship in a textile factory at the outset of his career had a strong impact in his conception of art-making. This is visible in his incorporation of repetitive patterns and forms encased in gridlike structures.

POWDER AJAX

Thomas Bayrle, who is also German but not affiliated with Capitalist Realism, or with Block's gallery, created *Ajax* (1966; opposite), a work that enters into a similar dialogue with advertising. Taking the form of an Ajax-branded industrial cleaning powder, Bayrle's painting stood out as a reaction to the frenzy around cleanliness, which took over post-war Germany. Cleaning was a metaphor for the contemporary obsession with the house while also emerging as a manifestation of a wider need felt by many Germans to cleanse in the wake of its recent Nazi past. The many cleaners covering the surface of Bayrle's *Ajax* represent these two national trends towards tidiness.

KEY WORDS
Consumer products, Coca-Cola, Coca-colonization, Campbell's soup, toys, food, packaged goods, The Store, pastries, Capitalism Realism, moral and material cleansing, ritual, parody, politics of food

KEY ARTISTS
Jasper Johns, Andy Warhol, Robert Rauschenberg, Ushio Shinohara, Christa Dichgans, Erró, Derek Boshier, Claes Oldenburg, Wayne Thiebaud, K. P. Brehmer, Thomas Bayrle, Gerhard Richter, Konrad Lueg and Sigmar Polke

POP AT HOME

-

She wants furniture she likes,
but she also wants furniture in
good taste – furniture that will proclaim
her family status. The trouble is that she
does not know for sure what good taste
in furniture is, and the furniture
industry has confounded her
with a plethora of styles

-

Gilbert Burck

1959

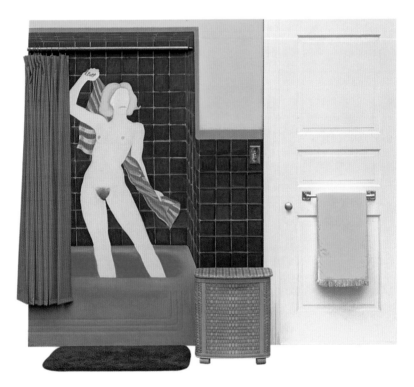

Tom Wesselmann

Bathtub #3, 1963
Oil on canvas, plastic,
various objects, 213 x 270
x 45 cm (83¾ x 106 x
17¾ in.)
Museum Ludwig, Cologne

**This work calls for the
viewer to become a
voyeur by stepping
into the intimacy of a
private bathroom.**

Following on from the plentiful goods that inspired Pop artists
across the globe, it is now time to turn to the home where many
of these goods were customarily consumed. The private home was
made public through Pop Art's frequent intrusion into its intimate
spaces. Pop artists, as will be shown in this chapter, portrayed
the home as a place where material goods were put on display
sanctioning the homeowner's status. At the same time the home
was subject to thorough scrutiny, especially those belonging to
middle-class Americans. They were targeted by artists from abroad
as a hotbed of self-fulfilling hypocrisy.

RICE KRISPIES, A PINK FRIDGE AND A BATHTUB

The American economy boomed in the years following the end
of the Second World War. The wealthiest country in the world,
America was a land of abundance emblematized by its sleek
household appliances, which at that point were within the reach
of most American families. While in Europe a television set was a
privilege that only few could afford up until the 1960s, in America
it was the norm by the mid-1950s. The 'American lifestyle',
symbolized by goods like a television, a fridge and a car, was still only
a longing for many Europeans while a reality for many Americans.

**Wesselmann pointed to a dehumanizing process whereby
material goods increasingly overpower human beings**

The American painter Tom Wesselmann made the American
lifestyle a recurrent theme in his work. Focusing specifically on
bathrooms and kitchens, he depicted the desires and the fulfilment
of the American Dream through its most banal private spaces
combined with its most typical goods. Wesselmann offers a view
into the middle-class American home, unspecific and yet desirable.

With *Bathtub #3* (1963; opposite), Wesselmann leads us into
the intimacy of a bathroom. A painting but also a sculpture, which
combines real bathroom fixtures with painted elements, *Bathtub #3*
is specific in its representation of the bathroom but almost abstract
in its treatment of the figure showering in the bathtub. Reduced to
a flat white silhouette, the woman showering is, despite showing her
genitalia, far from erotic. By making her less real than the objects
surrounding her, Wesselmann pointed to a dehumanizing process
whereby material goods increasingly overpower human beings.

In *Still Life #30* (1963; opposite), the setting changes from a bathroom to a kitchen. Like *Bathtub #3*, *Still Life #30* also features a combination of real objects, such as the pink fridge door, and painted ones, like the oranges on the windowsill. Speaking of his use of multiple media, Wesselmann has stated: 'One thing I like about collage is that you can use anything, which gives you that kind of variety; it sets up reverberations in a picture from one kind of reality to another.' And along similar lines he went on to stress: 'I use real objects because I need to use objects, not because objects need to be used. But the objects remain part of a painting because I don't make environments. My rug is not to be walked on.' Making a stark distinction between a spatial environment, into which the viewer is invited to step and move around the objects, and a painting simply devised to be observed, Wesselmann invites his viewers to look from a respectful distance.

-
This scene concentrates solely on the objects and goods that give the kitchen its middle-class status
-

In *Still Life #30*, Wesselmann focused on the kitchen where the aproned housewife would cook the family's delicious meals. No humans, however, are included in this scene, in which the artist concentrates solely on the objects and goods that give the kitchen its middle-class status. The contents of the fridge remain out of view, but we are led to imagine that it is filled with treats of the kind set out on the chequered blue-and-white tablecloth. Reflecting on the banality of the American household, Wesselmann assembles and paints a deadpan rendering of the American Dream.

Tom Wesselmann
Still Life #30, 1963
Oil, enamel and synthetic polymer paint on composition board with collage of printed advertisements, plastic flowers, refrigerator door, plastic replicas of 7-Up bottles, glazed and framed colour reproduction and stamped metal, 122 x 167.5 x 10 cm (48½ x 66 x 4 in.)
The Museum of Modern Art (MoMA), New York

The result of a supermarket outing, the products on the table, such as sliced bread, pancakes covered in maple syrup and Rice Krispies, are the quintessential foods found in every American home.

LULLABY

The domestic interior could also be referenced through a self-standing object. Oldenburg pioneered this approach with his soft sculptures depicting a range of different objects from toasters to drain pipes. The Colombian artist Beatriz González also turned to household furniture to reflect on domesticity and the spread of images more generally. One of the first artists from her generation to turn to the mass media for inspiration, González aspired to bridge the gap between popular imagery and fine art. She was specifically interested in how renowned European masterpieces, such as Leonardo da Vinci's *Last Supper*, were being reproduced by

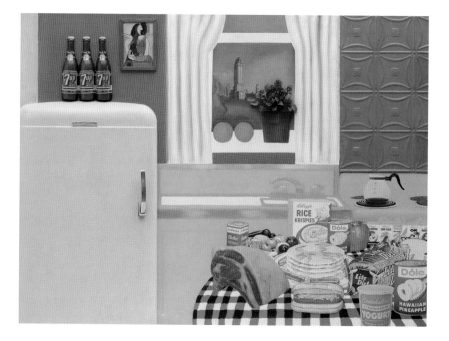

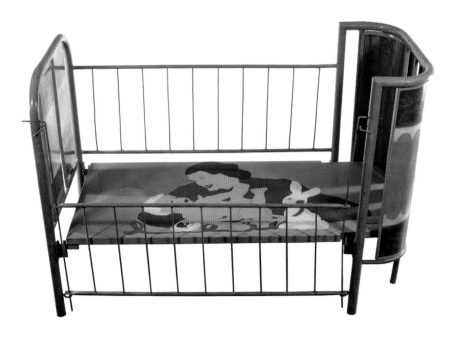

local artists who, without having ever seen the original works, made cheap replicas ridden with imprecisions. Having collected these reinterpretations of Old Masters, González went on to reproduce them in her own work.

The absence of a real mother and child, with just a flat kitsch stand in, gives *Lullaby* slightly haunting overtones

In *Lullaby* (1970; above) a classic image of a Madonna and Child is reproduced onto a metal sheet, mounted in turn on a mass-produced crib. One of González's furniture pieces, the crib, like the tables and dressers in the same series, juxtaposed an art historical image with a cheap mass-produced piece of furniture. A comment on mass production and consumption, the artist's domestic pieces were rooted in the kitsch language of Colombia's mass culture. The image of the Madonna and Child featured in *Lullaby* was taken from a series of kitsch photographs available through a Colombian print company. The popular image fittingly matches the crib itself, a leftover from a public hospital. Both the Madonna and Child, with its

Beatriz González
Lullaby, 1970
Enamel on metal,
70 x 150 x 105 cm
(27½ x 59 x 41⅜ in.)
Museum of Modern Art
(MoMA), New York

The appeasing lullaby tune is a stand in for the bond between mother and child.

Erró
*An American Interior
No. 7*, 1968
Acrylic on canvas, 115 x
90 cm (45¼ x 35½ in.)
Ludwig Forum für
International Kunst,
Aachen

Erró's *American Interiors* drew on a range of settings, including kitchens, bedrooms and bathrooms.

direct maternal reference, and the crib as an object imply femininity. The absence, however, of a real mother and child, with just a flat kitsch stand in, gives *Lullaby* slightly haunting overtones.

DEPOSING THE DOMESTIC GODDESS

The absent persona from all the objects, paintings and environments that we have considered so far is the domestic goddess, the angel of the house or, more plainly put, the housewife. At the heart of the family unit, the housewife is in charge of the home, takes pride in the way it looks and gains satisfaction from looking after it perfectly. Aided by the household products that advertisements have lured her to buy, she is able to assemble the perfect kitchen, the perfect bedroom, and so on.

But what happens if the domestic goddess disappears or, worse, is replaced by Viet Congs? Absurd as this question may sound, it was not entirely out of place in the 1960s, a time when, as we have seen, television brought the news of the Vietnam War into people's

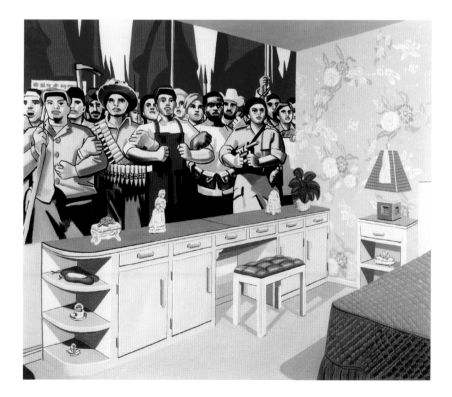

homes. The violence of the war entered even into the most perfectly ordered living room.

Erró revealed in his series *American Interiors* the inextricable ties linking the middle-class home with the political tensions coming from abroad. In *An American Interior No. 7* (1968; page 101), the artist places the viewer in a manicured bedroom of the kind faithfully replicated by Oldenburg in his *Bedroom Ensemble*. The unexpected feature here is the group of guerrilla fighters of Communist orientation stepping into the middle-class room. Commenting on the exploitative nature of the American economy, which thrives on the abuse of third-world countries, Erró's painting seems to imply that the established order could soon be overturned. Besides the painting's strong contents, the images at the core of the *American Interiors* series were taken from a catalogue for an American paint factory that Erró came across in Cuba in 1967.

Like Erró, Martha Rosler used the domestic goddess to reveal the haunting side of domestic interiors. *Balloons*, from the series *House Beautiful: Bringing the War Home* (c.1967–72; opposite), transports the horrors of the Vietnam War into the safe confines of the American home. A true activist since her adolescence, Rosler turned to Pop Art as an instrument to raise peoples' social and political awareness. In this instance, by inserting images of the Vietnam War extracted from *Life* magazine into the interiors featured in the glossy magazine *House Beautiful*, Rosler combines two starkly divergent realities: war and home. The grieving Vietnamese mother carrying her wounded child revealed the suffering of civilians whose lives were constantly bombarded by US military attacks. A stark warning that the war was as much 'here' as it was 'there', Rosler's series *Bringing the War Home* questioned the American lifestyle and its ideals.

Martha Rosler
Balloons, from the series *House Beautiful: Bringing the War Home*, c.1967–72
Photomontage, dimensions variable
Art Institute of Chicago, Chicago

The tranquillity of a home – where the coloured balloons stashed by the entrance, call to mind a birthday party filled with fun and joy – is juxtaposed with the misery of the Vietnamese woman's perilous situation.

KEY WORDS

Domestic interior, still life, bathroom, kitchen, bedroom, furniture, housewife, intimacy, American Dream, mass production, war, violence, conflict

KEY ARTISTS

Tom Wesselmann, Claes Oldenburg, Beatriz González, Erró, Martha Rosler

POP GIRLS

-

We broke through the feminine mystique
and women who were wives, mothers and housewives
began to find themselves as people. That did not
mean they stopped, or had to stop, being mothers,
wives or even liking their homes

-

Betty Friedan

1992

Women have long been one of art history's favourite subjects along with history painting (see pages 20–39). For example, the tradition of the reclining nude extended from Titian to Matisse all the way to Wesselmann, who paid tribute to this subject in his *Great American Nudes*' series. Sensually reclining, women are given a passive role. Objects of mere contemplation, they lend their bodies to depictions of desire and femininity. But what if conventions were overturned and women went from being observed to art makers? And what if female nudity became an instrument in the sexual liberation movements, blossoming in the 1960s? In this chapter women and the female body are charged with unexpected meanings. Pop Art has conventionally been the terrain of male artists, but here we consider not only the contributions of women to the movement, but also the ground they broke with their erotically provocative works.

Martha Rosler
Hothouse or *Harem*, from the series *Body Beautiful* or *Beauty Knows no Pain*, c.1966–72
Photomontage, dimensions variable
Private collection

Rosler's early photomontages were Xeroxed and distributed during street protests and reproduced in underground magazines.

PLAYBOY AND PLAYMATES

> *Playboy* was not planned as a publication for the idle rich, so
> much as in recognition that with the prosperity of post-war
> America, almost everyone could have a piece of what we
> described as *the playboy life* – if he were ready to expend the
> necessary effort.

This extract was published in *Playboy* in 1964 by Hugh Hefner,
the founder of the lifestyle magazine for men. *Playboy* offered
all men access to its wondrous naked beauties, as well as lifestyle
advice, fiction and poetry. For the modest sum of 50 cents (in
1953 when it was first published), *Playboy* made eroticism and
entertainment a widely accessible good. As Hefner dictated

'everyone could have a piece', and the centrefolds featuring sensually posed naked women (including Marilyn Monroe, among others) quickly became its hallmark. Women were *Playboy*'s protagonists but men were its target audience, leaving the playmates contained in its centrefolds to be mere objects of fond admiration.

Martha Rosler, in her *Hothouse* or *Harem* from the series *Body Beautiful* or *Beauty Knows No Pain* (1966–72; pages 106–7), subverts this hierarchy by presenting the viewer with a harem of female cut-outs from *Playboy*. The photomontage ironically shows how *Playboy* standardizes eroticism. All the women, regardless of race or background, pose in similar ways and sensually engage the magazine's readers. Through her collage Rosler seeks to draw attention to the commodification of the female body perpetrated by *Playboy*. A critique of the magazine's promotion and display of soft-core pornography at the expense of women's individuality, Rosler condemns *Playboy* and the mass media more generally for the beauty standards they promoted. Heavy make-up, elaborate hairdos and surgical enhancements all partake in the ideal of femininity that Rosler scrutinizes in this photomontage and in the series *Body Beautiful* or *Beauty Knows No Pain* more broadly. Now widely regarded as an iconic feminist work, *Hothouse* or *Harem* points viewers to the conflicting relationship between nudity and its representation in the mass media.

'There was no space for women in Pop'

Rosler was also vocal when it came to the perils suffered by female Pop artists. Marginalized in historical accounts of Pop Art, women have long been relegated to a peripheral role and only in recent years have their contributions to the movement resurfaced. Recalling her experience as a woman and as a Pop artist, Rosler claimed: 'There was no space for women in Pop . . . no room for the voicing of a different, "truly" female, subjectivity.' Female subjectivity, as Rosler lucidly points to, was in the hands of male Pop artists, who for the most part turned to the female body as an object to be appropriated and depicted in poses akin to those promoted by *Playboy*. By contrast the 'true' female subjectivity, which Rosler invokes here, was embraced by women Pop artists, whose work challenged stereotypical representations of femininity. For example, in her photomontage *Woman with Vacuum* or *Vacuuming Pop Art*, Rosler draws attention to the marginalization experienced by women

Martha Rosler
Woman with Vacuum, or *Vacuuming Pop Art*, from the series *Body Beautiful*, or *Beauty Knows No Pain*, c.1966–72
Photomontage, dimensions variable
Private collection

Rosler's artwork is a denunciation of enforced domestic labour.

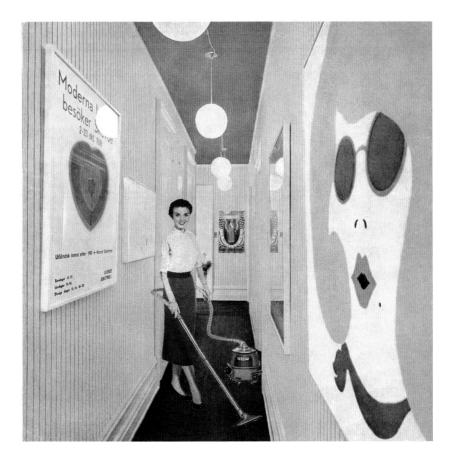

in a prevalently patriarchal society. While women are relegated to vacuuming, men make Pop Art. The ingenuous young woman at the centre of this work fulfils her household duties, while the male heroes of Pop Art (including Tom Wesselmann) fill the walls of the corridor with their paintings and posters.

DAMSEL IN DISTRESS

Lichtenstein is mostly credited and widely recognized for his Benday-dot technique, a painted simulation of the dotted effect of commercial printing, which the artist methodically applied to all of his work, starting with *Look Mickey*, from the early 1960s onwards. Commenting on the aesthetic import of this technique in an interview with John Coplans in 1970, Lichtenstein stated: 'The dots can have a purely decorative meaning, or they can mean an

industrial way of extending the color, or data information, or that the image is fake.' Acquiring a multiplicity of meanings, as illustrated by Lichtenstein's answer, the Benday technique had a huge impact on the artist's Pop work, becoming his hallmark style. Applied to a variety of subjects from the depiction of interiors to the replication of scenes lifted from comic strips, Benday dots were also used in Lichtenstein's portraits of women.

-

There is an implicit understanding that the drowning girl will be ultimately saved by her beau

-

Drowning Girl from 1963 (opposite) is exemplary of a group of works focusing on an isolated female head. A beautiful and tearful woman is depicted struggling to stay afloat amid the rough sea. Attractive and dignified despite the tense situation, using the thought bubble – a comic strip convention to which Lichtenstein turned regularly – the girl informs us that she is ready to fend for herself. She emphatically states: 'I don't care! I'd rather sink . . . than call Brad for help!' Brad is a stand in here for the stereotypical handsome male hero ready to come to the needy woman's rescue. Although the melodramatic charge of the scene appears to reject Brad's intervention, there is an implicit understanding that the drowning girl will be ultimately saved by her beau.

Lichtenstein's representation of women, as emblematized by *Drowning Girl*, is often based on their dependency on men. As Letty Eisenhauer, Lichtenstein's girlfriend at the time, explained these portraits were the result of the artist's own disillusionment caused by his divorce and his lingering desire to pursue a simple relationship based on female dependency. In Eisenhauer's words:

I believe the works were intended to express his pessimism about 'the love story.' He considered it hopeless, as he ironically stated in one of those 'crying girl' paintings [*Hopeless* (1963)]. He was not disappointed about his divorce, however, but about love. His cynicism was intensified by the short, unhappy love affair he had early in 1962 with a news-magazine photographer . . . who rejected him. He was deeply hurt by her, but he couldn't cry. The women in these paintings are crying over him. Roy wanted some beautiful Breck Girl [the classic blond in the adverts for Breck shampoo] to love him the way these women loved their men.

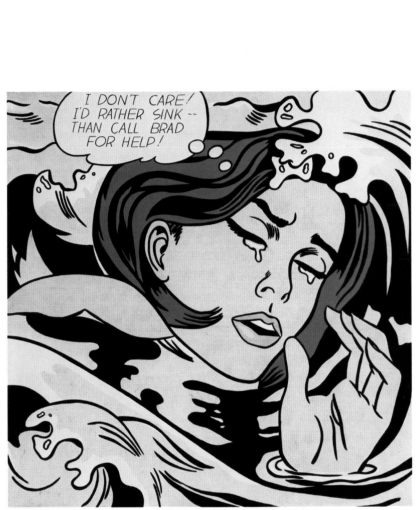

Not as overtly erotic as the depictions of female nudity challenged by Rosler, Lichtenstein's take on women – the idealized notion of love and the associated needy femininity – corresponded with the dominant narratives portrayed in contemporary soap operas, female literature and the mass media.

FOR MEN ONLY

The work of British artist Peter Phillips, *For Men Only – Starring MM and BB* (1961; opposite), is clearly sexually charged. Phillips made this work while he was still a student at the Royal College of Art in London. Albeit ironically, Phillips immediately confined the work to a male-only audience, a stance reinforced by two protagonists, the movie stars Marilyn Monroe and Brigitte Bardot. Like Monroe, Bardot had also been turned into a hyped sex symbol by the media. Phillips appropriated press photographs of the two actresses and collaged them onto a wooden panel. A leaping hare, an intentionally absurdist insertion, separates the movie queens from the lower section where the artist added a further element: a female stripper. A comment on stereotypical representations of female sexuality, *For Men Only – Starring MM and BB* speaks most directly to the readership and the ideals set forth by men's magazines, such as *Playboy*. Maintaining an ambivalent attitude towards representations of femininity, Phillips is indulgent as well as critical in this painting, but not in an outspoken a way, as in Rosler's *Harem*.

It was through the overtly sexual representation of femininity that Axell championed female emancipation

A SEXUAL REVOLUTION IN ART

The Belgian artist Evelyne Axell reversed the terms of female nudity so as not to emphasize sexist attitudes but rather to empower women. The famous French critic Pierre Restany characterized her work as 'a sexual revolution in art'. And indeed it was through the overtly sexual representation of femininity that Axell championed female emancipation. Starting her career as a film and theatre actress, Axell later turned to art as a channel to voice her ideals. At this time she changed her name to the gender-neutral 'Axell' as a further device to reassert her emancipatory ambitions. Through a distinctly feminine vocabulary, intentionally and ironically

Peter Phillips
For Men Only – Starring MM and BB, 1961
Collage, oil and wood on canvas, 259.6 x 153.1 cm (102¼ x 60¼ in.)
CAM collection – Calouste Gulbenkian Foundation, Lisbon

By the time he turned twenty-one in 1960, Phillips was already well versed in the Pop idiom. This caused a stir at the Royal College of Art in London where he was enrolled, forcing him to transfer to the television division.

provocative, she pioneered female eroticism as a means to invoke sexual and intellectual freedom. Speaking of her work she claimed:

> Above all my world is an unconditional 'joie de vivre,' in spite of its aggressive aspect. My motive is clear: nudity and femininity reflect a vision of the world in favour of a bio-botanical freedom, that is a freedom that resists both frustration and gradual binding, and one that is willing to accept only the restrictions it imposes upon itself.

Nudity was synonymous for Axell with freedom and resistance. These ideals were most clearly illustrated in *The Pretty Month of May* (1970; above), one of her most monumental and overtly political works. Modelled on the tradition of history painting, Axell revisited history here on her own terms. Taking as a starting point a now iconic photograph from the May 1968 student uprisings in Paris, the artist proceeded to repurpose the image so as to eliminate all male traces and set the scene for a female-only cast of characters. In the original image showing a group of protesters marching through the streets of Paris, the focus was on the artist and political

Evelyne Axell
The Pretty Month of May, 1970
Triptych, enamel paint on Plexiglas, 245.5 x 344.5 x 4.5 (96⅝ x 135⅝ x 1¾ in.)
Mu.Zee, Ostend

The title of this work ironically alludes to the political and social upheavals of May 1968.

activist Jean-Jacques Lebel who was carrying Caroline de Bendern waving a Vietnamese flag on his shoulders. By erasing Lebel from the scene and replacing him and the other marchers with an army of voluptuous and sexually provocative women who surround de Bendern, now brandishing a red flag, Axell shifts the emphasis from the anti-war and student uprisings to female liberation.

A portrait of Axell is inserted in the right-side panel as a testament to the artist's active participation in this call-to-arms of sorts. She holds a paintbrush, the tool of her trade, with which she invokes her ability to tell and make a new woman-centred history through her works. Restany is on the left-hand side, acting as a counterpoint to Axell as she paves the way to this dramatic gender shift. Representing the male gender, the critic in his priestly guise, enveloped in a white robe, addresses the unruly crowds of women, which take no notice of his words. By reclaiming female sexuality from the world of mass media, Axell endows female nudity with a meaning other than simple objectification and ultimately turns it into a powerful tool of protest.

VACUUMED BRIDE

Overturning women's socially prescribed roles was also the premise of Spanish-Catalan artist Eulàlia Grau whose *Vacuum Cleaner* (page 116) from the series *Ethnographies* (1973) undermined the traditional understanding of women as angels in the house or domestic goddesses as discussed in the previous chapter.

**The newly wed bride is being sucked up by
a flaming brand-new vacuum cleaner**

Pictured here is a doll dressed up in a wedding dress holding a flower bouquet in one hand. The newlywed bride is being sucked up by a brand-new vacuum cleaner – a household object that should make her life more pleasant but which turns out to be an enemy rather than an aide. A metaphor for the false promises of peace and serenity typically associated with the ideal of housewife, Grau's work points here to its darker side, ridden with constraints. Testifying to the restrictions placed on women by the conservative military dictatorship of General Francisco Franco who was ruling over Spain at the time, *Vacuum Cleaner* is only one of the social and political issues that Grau sought to expose through her series

Eulàlia Grau
Vacuum Cleaner, from the series *Ethnographies*, 1973
Photographic emulsion and paint on canvas, 164 x 110 cm (64½ x 43⅜ in.)
Museu d'Art Contemporani de Barcelona (MACBA), Barcelona

Grau's *Ethnographies* analyse the hierarchical structures, patriarchal conventions, gender relations and clichés of Spanish society in the early 1970s.

Ethnographies. This comprised works addressing social disparities, corruption and war. Setting out on a quasi-anthropological mission, as the title suggests, Grau mapped out the excesses and failures of contemporary society. The condition of women stood out as one of the issues in dire need of attention, both in Spain and abroad.

Jana Želibská, a graduate of the Academy of Fine Art in Bratislava, also drew attention to the female condition through her richly adorned objects. *Object II* (1967; opposite) presents the silhouette of a headless woman encased in a wooden box. Concealed by a thin veil (that the viewer is encouraged to open at his or her leisure), the female body is presented here as a mystical site of reverie and objectification.

Jana Želibská
Object II, 1967
Mixed media, mirror,
metal pelmet, textiles,
lace, wood, 148 x 70 x 50
(58¼ x 27¼ x 19⅝ in.)
Slovak National Gallery,
Bratislava

**Želibská was inspired by
the French movement
Nouveau Réalisme and its
use of non-art materials
in particular. These
included: lace, fabric,
neon, plastic and mirrors.**

LOVE & VIOLENCE

Motivated by a feminist urge Grau and Axell endeavoured to reclaim
a space for women in art – and in society in general. American artist
Rosalyn Drexler was not propelled by a similar feminist calling; her
works appear – at least on the surface – to suggest a very different
stance. Briefly pursuing a career as a professional wrestler and later
gaining recognition as a writer, penning among other things the
screenplay adaptation of *Rocky* (1976), Drexler turned to painting in
the 1960s. Despite women, and in particular their relationship with
men, being a prominent theme in her work, the artist has repeatedly
insisted that she was not working from a feminist stance. Concerned
more broadly with human relations she turned, like the great

majority of Pop artists, to contemporary media for inspiration. For example, 1950s B-movies offered a springboard for Drexler's *Love & Violence* series, which confronted the perpetration of violence inflicted upon women at the hands of men.

Exposing the violent dimension of love, *Love & Violence* (1965; opposite) evokes the unfolding of male brutality on the cinematic screen. In the upper section a woman turns away from a man who is aggressively demanding her attention; in the lower section a group of men, whose outfits and postures suggest that they might be gangsters, are fighting one another. The intensity of the red backdrop conveys an even stronger sense of escalating brutality. Raising the issue of violence more than vindicating women's rights, Drexler's *Love & Violence* nonetheless points to the potentially abusive nature of love and its effects on women. No longer the sensual objects of desire pitched by *Playboy*, women are confronted here with fear and danger, exposing yet another facet of how femininity was portrayed by the media.

Rosalyn Drexler
Love & Violence, 1965
Acrylic, oil over paper
collage on canvas, 173 x
155 cm (67¾ x 60¾ in.)
Private collection

Drexler's characters operate against flat colour fields, which abstract them from their original setting.

THE PARTY

Marisol was invariably included in Pop exhibitions along with her male counterparts in New York. Despite this inclusion and the huge success garnered by her solo shows, she was still marginalized in comparison with Pop Art's leading members. Her subjects were Pop but her style was not. Woodcarving was considered too traditional and too close to folk art to match the lust for novelty and sleekness pursued by Pop. However, her portraits of fellow artists like Warhol to the movie star John Wayne and the political leader French President Charles de Gaulle were most definitely Pop. Marisol showed fluency in the Pop idiom but did so on her own terms. This was best expressed by her constant pursuit of female portraiture. The artist's own image was often a starting point. Writing in the *New York Times Magazine*, Grace Glueck, portraying the artist with a mix of admiration and disregard, stated:

> The Marisol legend is nourished by her chic, bones-and-hollows face (elegantly Spanish with a dash of gypsy) . . . her mysterious reserve and faraway, whispery voice, toneless as a sleepwalker's . . . Though these attributes are not to be sneezed at, Marisol's real fame rests on a dazzling ability to distill art from the clichés of American life. And indeed the American lifestyle with its idiosyncrasies was one of Marisol's favoured subjects.

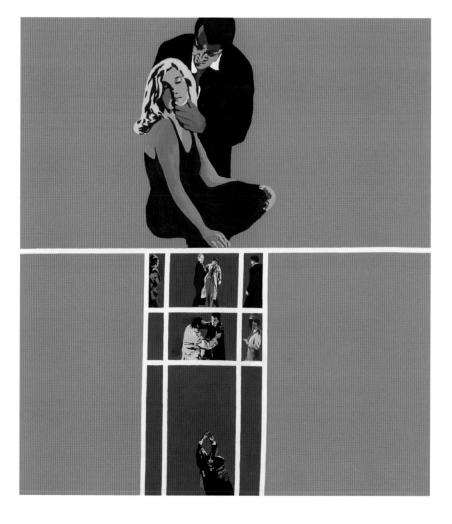

Among the artist's most spectacular pieces is *The Party* (1965–6; opposite). Included in Marisol's popular solo show at the Sidney Janis Gallery in New York in April 1966, *The Party* was widely praised for its poignancy in depicting social types. Consisting of fifteen life-size socialites, all richly decked out and bejewelled, they appear not to relate or have any intention of relating to one another. Looking in different directions and carrying on as independent entities, they are suddenly united to the viewer's surprise by sharing one common feature: Marisol's face. Whether carved or encased within a television screen, the artist hauntingly appears in every party-goer.

Inspiration for this work, as Marisol explained, came 'from meeting those kinds of society people. It was some kind of commentary on that experience.' She continued:

> I mean I wasn't making some beautiful women having a good time. That's a criticism. I didn't like talking to women, then. They would tell me I had to get dressed up like a model and get a man to pay the bills. Models were very popular in the art world of the sixties.

Marisol's *The Party* addressed a feminine issue without taking a feminist standpoint; it comments on the society of adorned but hollow women that could be encountered in New York's upper-class social circles. Far from Rosler's outspoken feminist consciousness-raising commentary, as explored with *Harem*, Marisol's work nevertheless focused critically on female clichés. She is one of many female Pop artists whose contributions to Pop Art deserve more attention.

Marisol (Escobar)
The Party, 1965–6
Assemblage of fifteen
freestanding life-size
figures and three wall
panels, with painted and
carved wood, mirrors,
plastic, television set,
clothes, shoes, glasses,
and other accessories,
dimensions variable
Toledo Museum of Art,
Toledo, Ohio

**Early critics highlighted
the sinister undercurrent
of *The Party*, ascribing to
the assemblage deathly
qualities and commenting
on the frightening nature
of the isolated figures.**

KEY WORDS

Women, female body, nudity, sexual liberation, female empowerment and emancipation, freedom, rebellion, love, violence, May 1968, Hollywood B-Movies, parties and socialites, *Playboy* magazine

KEY FIGURES

Marilyn Monroe, Brigitte Bardot

KEY ARTISTS

Martha Rosler, Roy Lichtenstein, Peter Phillips, Evelyne Axell, Eulàlia Grau, Rosalyn Drexler, Jana Želibská, Marisol

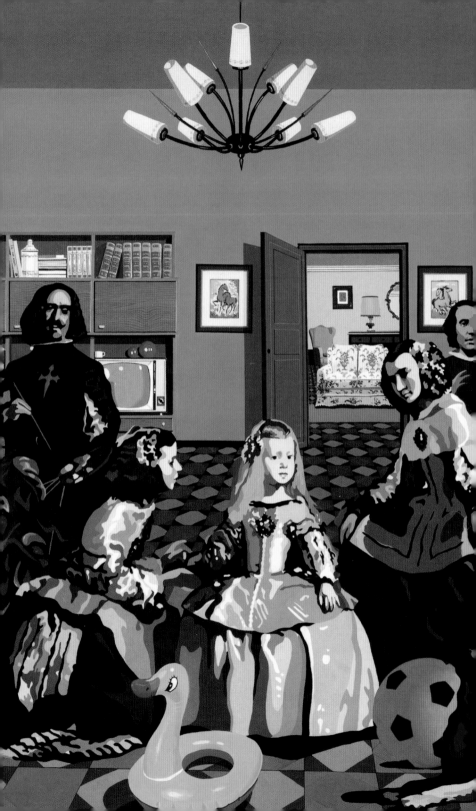

POP AND
ART HISTORY

-

**Pop art is thought to be the art of
the everyday things and banal images – bathroom
fixtures, Dick Tracy – but its essential character
consists in redoing works of art**

-

Harold Rosenberg

1969

In its rapacious appropriation of images, Pop turned to art history, too. Masterpieces by Édouard Manet and Diego Velázquez were readily hijacked by Pop artists and revisited through Pop Art's characteristic bold, bright colours and simplified imagery. The idea was to remove from the masterpiece its historical aura and turn it into a mundane subject on a par with images of Campbell's soup cans and the latest political icon. Contemporary means of reproduction, from photographic screenprints to magnified photographs, were employed by Pop artists to reproduce the works of their forefathers. The use of these mechanical processes further detached contemporary Pop versions of masterpieces from their original sources, which for the most part had been exquisitely crafted through subtle shading and painstaking brushstrokes. Playing on the immediate recognizability of their sources, Pop artists forced their audiences to consider how the language of Pop could reinterpret even the most well-known paintings.

Alain Jacquet
Le Déjeuner sur l'herbe, 1964
Acrylic and screenprint on canvas, two panels: 172.5 x 196 cm (68 x 77 in.)
Musée National d'Art Moderne, Centre Georges Pompidou, Paris

Together with fellow artists Mimmo Rotella and Pol Bury (among others), Jacquet was an exponent of Mec Art (mechanical art) – a movement aimed at exposing the relationship between painting and mass production.

LUNCHING ON THE GRASS WITH MANET

The French artist Alain Jacquet, who had superimposed Sandro Botticelli's iconic Venus from his *Birth of Venus* (1484) on a Shell-branded fuel dispenser in his painting *Camouflage Botticelli (Birth of Venus)* (1963–4), turned to another quintessential masterpiece: Édouard Manet's famous *Déjeuner sur l'herbe* (Luncheon on the Grass; 1863). Manet's painting had sparked a great deal of controversy when it was first exhibited. Featuring a scantily dressed woman seated in the company of two fully dressed young men, the painting was viewed as running against a common sense of propriety with its realistic style and its nuanced reference to prostitution.

A century later with his *Déjeuner sur l'herbe* (1964; opposite), Jacquet revisited Manet's original scene. Based on a snapshot featuring three friends of Jacquet's seated in a garden, the photograph is greatly magnified. Blurry to the point of abstraction, Jacquet's *Déjeuner sur l'herbe* is a comment on Manet's original work and shows the possibility to update it. It is the photographic process that takes centre stage in this work. Through superimposing mechanical processes onto the existing painting, Jacquet endeavoured to explore different visual effects through distortion and variation. In keeping with this mechanical take on Manet's masterpiece, Jacquet went on to reproduce this work in almost a hundred versions of varying sizes.

OLYMPIA GOES BLACK

Like many of his peers, the American artist Larry Rivers was drawn to recognizable images. As he explained: 'As far as I'm concerned nothing makes an invented shape more moving or interesting than a recognizable one. I can't put down on canvas what I can't see. I think of a picture as a smorgasbord of the recognizable.' Comparing pictures to a buffet meal, Rivers asserts the prominence of pre-existing images over invented ones. As part of this belief, he also turned to Manet's opus as an inspiration. However, the purpose of his reinterpretation was not process driven, as Jacquet's was, but was aimed instead at drawing attention to contemporary civil rights and racial equality struggles.

Rivers plays with the characters' skin colours to draw attention to civil rights

Having brought thousands of Americans onto the streets, the civil rights movement was central to American politics in the 1960s (see pages 44–8). Larry Rivers shows his awareness of this in *I Like Olympia in Black Face* (1970; opposite). Taking Édouard Manet's *Olympia* (1863) as a starting point – which, like *Le Déjeuner sur l'herbe*, had proved controversial – with its overt reference to prostitution, Rivers reviews the French painting in the light of contemporary social tensions. Doubling Manet's *Olympia* from one to two reclining figures accompanied by two cats and two servants, Rivers plays with the characters' skin colours to draw attention to civil rights. The enticing white *Olympia*, deriving from Manet's painting (which was modelled on Titian's classic *Venus of Urbino* 1538) is paired in Rivers' contemporary take with a black nemesis.

The two competing Olympias suggest the possibility of overturning white supremacy over blacks in American society. Even more noticeable is the reversal of the servant from black to white. Carrying a bunch of flowers, traditionally interpreted as a gift from a wealthy patron of Olympia's, the servant is ignored by the promiscuous protagonist turning her undivided attention to the viewer. Rivers's reversal from black to white refers to the legacy of slavery, which had long plagued American society. The cat, which has also changed colour, further reinforces the need to review societal structures. Rivers replaced the black cat –a symbol of prostitution in Manet's painting – with a purified white one, symbolic of a new order in the making.

Larry Rivers
I Like Olympia in Black Face, 1970
Oil on wood, canvas with plaster, plastic and Plexiglas, 182 x 194 x 100 cm (71⅛ x 76¼ x 39¼ in.)
Musée Nationale d'Art Moderne, Centre Georges Pompidou, Paris

With this work Rivers extends the subversive nature of Édouard Manet's iconic *Olympia* to the present day.

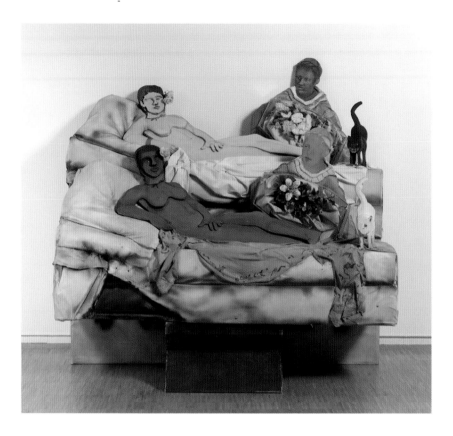

VELÁZQUEZ AND THE INFLATABLE DUCK

The Spanish collective Equipo Crónica drew on their national heritage by reinterpreting the works of Velázquez, one of the most iconic painters of Spain's Golden Age. Best known as a portraitist, Velázquez was a favourite of the Spanish royal family whom he regularly portrayed. *Las Meninas* (1656), featuring the young Infanta Margarita Teresa surrounded by her attendants and ladies in waiting, is widely regarded as Velázquez's most outstanding masterpiece. Equipo Crónica, in their *The Living Room* (1970; page 128), appropriate Velázquez's painting. While the core of the painting with its emphasis on the young Infanta is maintained many secondary details, and the setting itself, have undergone extensive updating. Most noticeably the lavish interiors of the Royal Alcazar in Madrid have been replaced by a middle-class living room, which also gives the painting its title. With its Formica furniture, television

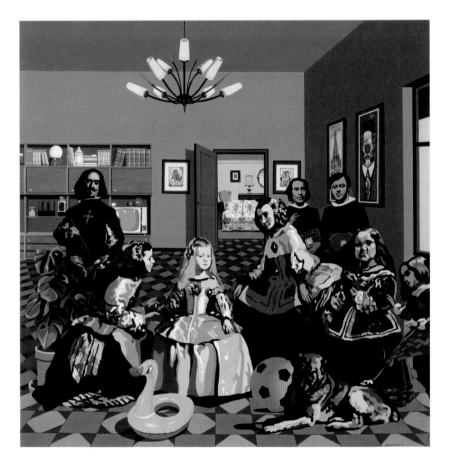

set and cheap posters on the wall, the banality of the living room in which the Infanta is revered undermines her status. Similarly aimed at debunking the awe shown towards the Spanish court and revoking the original painting's iconic standing is the inflatable duck rubber ring and the soccer ball lying on the living-room floor. Here Velázquez, who is depicted in *Las Meninas* painting the scene, is left without a canvas, with just a brush in hand, ironically hinting at how modern mechanical processes were increasingly removing artists from the traditional use of a paintbrush. The group also 'customized' iconic works by El Greco, Francisco Goya and Pablo Picasso.

Equipo Crónica
The Living Room, 1970
Acrylic on canvas, 200 x 200 cm (79 x 79 in.)
Museu Fundación Juan March, Palma

The inclusion of unlikely contemporary objects, such as the inflatable duck rubber ring, sets the playful tone of the scene.

THE REVIVAL OF BOTTICELLI

In the same way that Equipo Crónica returned over and over again to Velázquez as a source of inspiration, a group of Italian artists working along Pop lines turned to their own loaded historical past. Feeling plagued by such a rich but overbearing heritage, artists like Mario Ceroli and Giosetta Fioroni felt the urge to confront the iconic Renaissance artist Sandro Botticelli, through the reinterpretation of his celebrated *Birth of Venus* (1482–5). Using wood Ceroli crafted a three-dimensional reinterpretation of Botticelli's goddess titled *Goldfinger/Miss* (1965; page 130). By repeating Venus's silhouette with her flowing hair and sensually posed stance seven times, Ceroli gave Venus the status of a branded product. No longer just a mythological character, Venus is degraded and becomes as recognizable as a Coca-Cola bottle.

**Transforming the historical Venus into
a contemporary token of beauty**

Reasserting the enduring value of the famous Venus, Ceroli endeavoured to turn her into a beauty emblem of the present age. With its double reference to both the James Bond film *Goldfinger*, released in 1964, and 'Miss', a shorthand for the well-known Italian beauty pageant Miss Italia, the title of the work suggests the transformation of the historical Venus into a contemporary token of beauty. One of *Goldfinger*'s most impressive effects had been the gilding of the latest Bond girl, Jill Masterson, played by Shirley Eaton. Ceroli carved his seven Venuses out of wooden planks with the aim of giving the impression of a uniform surface not too distant from the golden Bond girl.

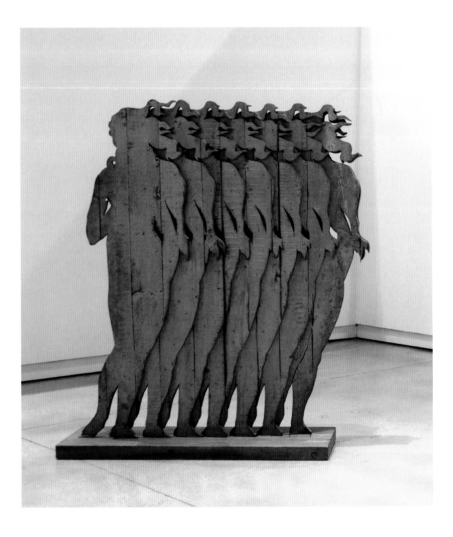

Above: Giosetta Fioroni
*Detail from the Birth of
Venus,* 1965
Oil on canvas, 100 x
200 cm (39⅓ x 78⅔ in.)
Intesa Sanpaolo
collection, Gallerie
d'Italia, Milan

**The inspiration for these
layered Venuses came
in this instance from
photography and the
artist's fascination with
its flickering effects.**

The only female artist affiliated with the Italian strand of Pop
Art, Fioroni was also taken by the iconicity of Botticelli's *Venus* and
revisited the goddess in her *Detail from the Birth of Venus* (1965;
above). As with Ceroli's *Goldfinger/Miss*, Fioroni's *Venus* is also
subjected to multiple repetitions. Like Jacquet's use of mechanical
processes in his take on Manet's *Déjeuner sur l'herbe*, Fioroni also
aimed to replicate a look inspired by photographic and cinematic
lenses. Fioroni described the silver aluminium-based industrial
paint from which she made most of her paintings in this period as a
'non-colour'. Through its use, she sought to evoke the photographic
properties of found images and snapshots. Turning to pictures
representing stereotypical aspects of femininity from elegance to
astonishment, Fioroni engaged with female beauty and showed a
fascination for the legacy of historical Italian paintings. She claimed:

> I am finishing off a group of paintings inspired by known images
> of Italian painting: Botticelli, Giorgione, Piero di Cosimo,
> Simone Martini, Carpaccio. I like to take the narrative whole
> of the old painting and pinpoint a detail, which becomes the
> primary element in my new painting . . . A group of young
> painters working in Rome feels obsessed in various respects with
> the sense of the past, understood and recounted in the most
> contemporary way imaginable, even like news item.

Opposite: Mario Ceroli
Goldfinger/Miss, 1965
Gilded wood, height:
166 cm (65⅓ in.)
Museo d'Arte
Contemporanea
(MACRO), Rome

**Ceroli retained the wood's
natural veining, a trait
that gives the work a
handmade quality.**

Detail from the Birth of Venus married Fioroni's interest in the
representation of femininity with the desire to take a single detail
from a famous work of art and treat it as a news item.

So far we have seen the reasons that led Pop artists across Europe to turn to well-known masterpieces were far from celebratory. The plagiarism to which they all subjected old and modern masters was dictated by an interest in the manipulation of images rather than in their content.

FUTURISM REVISITED

Like Ceroli and Fioroni, Mario Schifano belonged to a group of Italian artists known as La Scuola di Piazza del Popolo who worked along the lines of Pop in Rome. Rather than being fascinated by a single work of art, Schifano turned to a movement: Futurism. Italy's most important avant-garde group in the early twentieth century, the Futurists' inflammatory manifestoes sought to overturn the established order and promote the future over the past.

In a series of paintings broadly grouped under the name *Futurism Revisited*, Schifano appropriated a photograph of the five leading Futurists: Luigi Russolo, Carlo Carrà, Filippo Tommaso Marinetti, Umberto Boccioni and Gino Severini. Taken on the occasion of their first exhibition in Paris in 1912, a photograph marked a momentous turning point in the history of Futurism. It was used by Schifano at a time when the movement was being rediscovered. Having fallen out of favour owing to its connections with Fascism, Futurism's pioneering and utopian ideals were reviewed in the post-war era.

Schifano revisited his Futurist forefathers using a flat and colourful style typical of Pop Art as demonstrated in *Futurism*

Mario Schifano
Futurism Revisited in Colour, 1965
Acrylic on canvas, coloured Perspex, 170 x 300 cm (66⅞ x 118 in.)
Private collection

Schifano repeatedly 'revisited' the theme of Futurism in a number of works from this period.

Revisited in Colour (1965; opposite). He abstracts the image from its figurative roots by breaking it down geometrically into squared sections. Each square is then individually coloured and covered with a Perspex box. Like many Pop artists, Schifano showed a fascination with new materials such as plastic and its derivatives.

THE PERSIAN POET

Up until now we have considered only works made by American and European artists appropriating European masterpieces or movements. The phenomenon surrounding the reinterpretation of historical heritage, however, extended across the globe. Many artists felt the need to broker what was often perceived as an overbearing historical legacy. Their search for a new language looked back on pre-existing motifs for inspiration.

Parviz Tanavoli
*The Poet and the Beloved
of the King*, 1964–6
Wood, tin plate, copper,
steel, fluorescent light,
Perspex and oil paint,
189.7 x 108 x 107 cm
(74⅝ x 42½ x 42¼ in.)
Tate Modern, London

**Tanavoli came back to
the theme of star-crossed
lovers, as well as other
traditional Persian motifs
and subjects, in his
silkscreens and woven
tapestries, too.**

The Iranian artist Parviz Tanavoli's sculptural assemblage *The Poet and the Beloved of the King* (1964–6; page 133) is a good example of this longing to create a bridge between artistic heritage and new forms. It is a brightly coloured sculpture made out of found objects, wherein some of the components are periodically set in motion through the use of electricity. Fusing the grilles and knobs, which he purchased from local bazaars, with traditional themes, Tanavoli overcame the fear of idolatry that had long maintained a hold over Islamic culture. Having studied in Paris and Milan, Tanavoli returned to Tehran with a strong knowledge of European art movements. This increased his desire, without trespassing on the ban on figuration, to renew Iranian art.

Along with a group of fellow artists, he was among the founding members of Saqqakhane – also known as Spiritual Pop – which actively sought to merge traditional motifs with a contemporary imagery. This is best shown in Tanavoli's case with the way he regularly turned to the love story at the core of Iran's epic poem *Shahnameh* (977–1010), where the sculptor Farhad is tasked with having to cut a passage through a mountain in order to obtain the hand of the Armenian princess Shirin, with whom he has fallen madly in love. As the story ends with the tragic death of Farhad, the lovers never come together. While Tanavoli did not seek to literally depict this epic tragedy, he nevertheless took the characters' historical resonance as a starting point for his interpretation, which uses modern forms in a still-restrictive Iran.

DOLL FESTIVAL

Japanese artist Ushio Shinohara is encumbered by a similar historical weight, but without the figurative restrictions of the kind imposed by Islam. In a series of paintings known as *Oiran* dating from 1965, the artist set out to update the image of the traditional Japanese *oiran* (high-class courtesans) depicted in woodblock prints of the Edo period (1603–1868). In his 'Doll Festival' exhibition held at Tokyo Gallery in 1966, Shinohara exhibited his large *Doll Festival* (1966; pages 136–7) shown through the brightly coloured lenses of Pop Art. Focusing on the annual festivities celebrating the growth and wellbeing of young girls, *Doll Festival* revisits this ritualistic passage using the mechanical methods typically ascribed to Pop Art. Traditional Japanese figures were refitted here with a Pop look through the use of contemporary plastics and fluorescent paints. A western figure wearing jeans has been inserted among the archaic figures, which include a parade leader, an *oiran* and a male prostitute

This western intrusion is particularly significant as it signals the increasing influence of America and its cultural exports like jeans, destined to erode national customs. As Shinohara had already made plain with his *Imitation Art* series, of which Rauschenberg's *Coca-Cola Plan* was an outstanding example (see page 83), America's imperialistic tendencies had to be countered by parodying its imports including Pop Art. Although Shinohara's works at Tokyo Gallery did not sell well, the exhibition was widely praised. Having addressed the struggle between modernization and tradition, *Doll Festival* remains a landmark work in the history of Japanese Pop.

POP ICONOCLASM

The Russians Vitaly Komar and Alexander Melamid, the founders of Sots Art (Socialist Art), turned against Pop Art. Set to counter the aesthetic regime and the propagandistic function of Socialist Realism, Sots Art, as Vitaly Komar has recently posited, was 'a very important means of self-cleansing from the hypnosis of Soviet propaganda, and, primarily a cleansing from oneself'.

They showed how transitory Pop Art could be by depicting its remnants following a hypothetical post-nuclear catastrophe

While all of the artists considered in this chapter were looking back to historical masterpieces and traditions, the Russian duo looked back on the art of the more recent past. By 1973 when Komar & Melamid made *Post Art No. 1 (Warhol*; page 138), Pop Art's heyday had passed. The stripped-down aesthetics of Minimalism and the restraint of Conceptualism had surpassed the brash and figurative aesthetic of Pop. Komar & Melamid's *Post Art* series consisted of six works: *No. 1* was devoted to Warhol's iconic *Campbell's Soup Can*, while the rest included reinterpretations of the works of Roy Lichtenstein, Jasper Johns, Robert Indiana, Tom Wesselmann and Peter Phillips. Komar & Melamid's approach to the fabled Pop works was iconoclastic. They showed how transitory this art could be by depicting its remnants following a hypothetical nuclear catastrophe. Warhol's *Campbell's Soup Can* is portrayed in *Post Art No. 1* as badly damaged, surviving as a patched-up crumbling fresco. Having relinquished their integrity and their stereotypical sleekness, Pop Art works were just another remnant from the past.

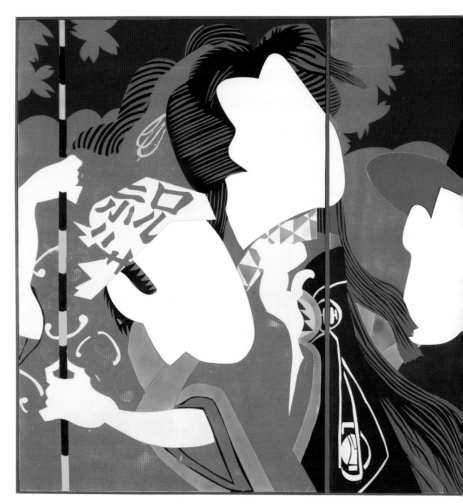

Ushio Shinohara
Doll Festival, 1966
Fluorescent paint, oil
paint, plastic board on
plywood, 196.1 x 399.7
cm (77¼ x 157⅓ in.)
Hyogo Prefectural
Museum of Art,
Kobe City

With a recommendation
from artist Marcel
Duchamp, Shinohara
secured a $2,000
grant from the William
and Norma Copley
Foundation in 1965, with
which he was able to
create his *Oiran* works.

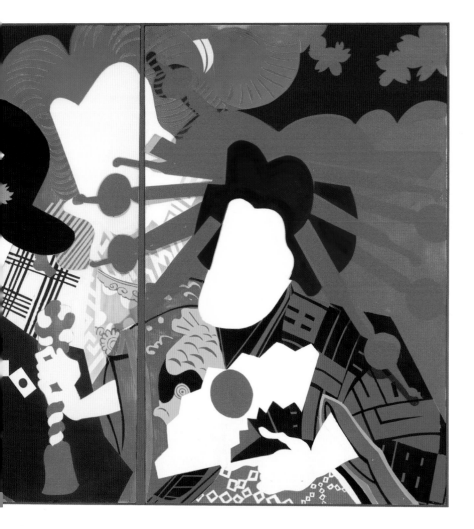

In the following quotation, Komar vividly recalls the context in which the *Post Art* series was made and exhibited – and, rather interestingly, the effect that *Post Art No. 1* had on Warhol when he viewed it:

Komar & Melamid
*Post Art No. 1
(Warhol)*, 1973
Oil on paint on
canvas, 121.9 x
91.4 cm (48 x 36 in.)

**Komar & Melamid took
part in the now famous
'Bulldozer Exhibition'
held in Moscow in 1974.
The exhibited works
were considered too
subversive by the
authorities who proceed
to bulldoze them.**

The samples used for the *Post Art* project were not originals but reproductions. In Russia in those days it wasn't possible to see the famous original Pop Art works so I hadn't seen them. The black and white reproductions from Soviet booklets criticizing the 'soulless West' were badly printed, like grey ghosts. But for *Post Art* we used brightly coloured pictures from the famous book by Lucy Lippard, *Pop Art* (1966), which was a priceless gift from an American student friend . . . 'a friend of a friend' carried many Sots-art paintings to New York. There in 1976 they were shown in an exhibition of Komar & Melamid at the Ronald Feldman Gallery. We were not allowed out of Russia for our own exhibition. The exhibition was unusually successful. Ronald sent us a bunch of reviews from newspapers and magazines. In his words, when Andy Warhol saw *Post Art No. 1 (Warhol)* and the future of his soup can, the face of this great artist turned as green as his beloved dollar bill. Only in 1978 was I able to get to New York and see the original Pop Art. It didn't differ much from the reproductions in Lippard's book.

KEY WORDS

Art history, old and modern masterpieces, civil rights movement, imitation, appropriation, tradition versus modernity, birth of Venus, Olympia, Futurism, *oiran*, Pop iconoclasm

KEY FIGURES

Édouard Manet, Diego Velázquez, Sandro Botticelli, Andy Warhol

KEY ARTISTS

Alain Jacquet, Larry Rivers, Equipo Crónica, Mario Ceroli, Giosetta Fioroni, Mario Schifano, Parviz Tanavoli, Ushio Shinohara, Komar & Melamid

POP AND
THE SPACE RACE

-

That's one small step for man,
a giant leap for mankind

-

Neil Armstrong

1969

Space was another arena where the Cold War tensions between the Soviet Union and America played out. Unfolding over the 1950s and 1960s, the race to conquer space saw the two nations come head-to-head on numerous occasions. Initially the Soviets led the 'space race'. In 1957 they managed a double coup, sending Sputnik 1, the first satellite, into space, followed by the dog Laika, the first living being to orbit Earth on board the spacecraft Sputnik 2. The cosmonaut Yuri Gagarin ensured the Soviet Union's supremacy in the space-race challenge.

Joe Tilson
Transparency I,
Yuri Gagarin 12 April,
1961, 1968
Screenprint on Perspex,
30 x 30 cm
(11¾ x 11¾ in.)
Private collection

The image oozes confidence as Gagarin emerges victorious from this mission, not only as an cosmotronaut but also as an emblem for the powerful Soviet Union.

-

The media actively contributed to the hype surrounding space exploration

-

On 12 April 1961, Gagarin with his spacecraft Vostok completed the first orbit of Earth. As the first man to return from space, he quickly became a worldwide celebrity. An event of an unprecedented scale, it was thoroughly covered by the media, which actively contributed to the hype surrounding space exploration. From reports on television to special issues in magazines, space entered virtually every household in the west, capturing imaginations and keeping people in suspense for the next chapter in the race to dominate space. Pop artists, with their thirst for glamour, fame and the everyday, were similarly lured by the potential of space and closely followed the space race.

HEROES OF SPACE

Joe Tilson turned to a televised image of Gagarin that sanctioned the cosmonaut's iconic status in his *Transparency I, Yuri Gagarin 12 April, 1961* (1968; opposite). Gagarin is shown here as he peers out of his spacesuit into the cosmos of which he is the very first man to conquer. By capturing this triumphal moment, Tilson's *Transparency I* acts as a tribute to the cosmonaut's epic voyage, while also stressing television's power to enhance the hype around the event. Using the television set's familiar black frame with rounded edges, Tilson clearly referenced the source of this image of Gagarin.

Gerald Laing's *Astronaut IV* (1963; page 144) acts as a counterpoint to Tilson's celebration of Gagarin's successful mission. Like Tilson and many of their contemporaries who had graduated from St Martin's School of Art in London, Laing fell under the spell of the space race. Alan Shepard, the first American astronaut to

be sent into space in 1961, was the protagonist of Laing's *Astronaut IV*. A direct result of the rivalry between the two Cold War powers, the mission proved less successful than the Soviet one. Shepard made it into space but did not succeed in fully orbiting Earth. Laing nevertheless celebrates Shepard's spatial feats in *Astronaut IV* where he reproduces an image of an astronaut found in a newspaper.

The main difference between how Laing and Tilson depict the first exploration into space is the way in which Tilson makes television's influence explicit. Television, as a medium capable of bringing the astronaut to one's living room, acts as a screening device, whereas Laing's unfiltered portrait of Shepard appears more heroic and is more emotionally charged.

Gerald Laing
Astronaut IV, 1963
Oil on canvas, 145 x 107 cm (57 x 42 in.)
University of New Mexico Art Museum, Albuquerque

The astronaut is shown taking off into space in the upper part of the shaped canvas. The flames in the lower section suggest the propulsion necessary to send the spacecraft into outer space.

Martial Raysse
Espace zéro, 1963
Silver paint and oil on
mounted photograph
on canvas, bulb and
electrical system,
102.5 x 83.5 x 8.3 cm
(40¼ x 33 x 3⅛ in.)
Private collection

**The light bulb, like
many of the neon lights
that appear in Raysse's
paintings of this time,
was meant to emphasize
the artificiality of
contemporary society.**

NEON ASTRONAUT

The French artist Martial Raysse was also enthused by the space
race and the way astronauts were increasingly seen as latter-
day heroes. Raysse's *Espace zéro* (1963; above) enhanced the
astronaut's quasi-mythological status: fluorescent colours and neon
props are meant to extend his extra-terrestrial powers. Although
furthering the myth of the astronaut generally, here Raysse pictures
specifically the American astronaut Gordon Cooper. Renowned for
being the first American astronaut to sleep in space, Cooper during
his 1963 mission orbited Earth a number of times.

Cooper's mission exemplified America's increasing success in
the space race, which would culminate with Neil Armstrong setting
foot on the moon on 20 July 1969. Interested in the aesthetic of
consumer culture, with its coloured commodities and inexpensive
found objects, Raysse consistently turned to fluorescent colours
in his paintings. As he once stated: 'I seek in transcendental

colour a substitute for life.' Commenting on his working method, he declared:

> Not only with a brush or with a trowel is it possible to create a work of art, but also with a printing machine or a photographic camera; in short, with any modern tool that the world makes available to us. It is this idea that has led me to invent my trade.

Xerox machines and cameras were at the heart of Raysse's art, which made extensive use of the latest technologies. The face of Gordon Cooper is a photocopy of a found image of the astronaut, which Raysse then overpainted with his fluorescent hues. Ultimately Raysse's *Espace zéro* is a tribute to Cooper as much as to the latest mechanical reproduction methods adopted by the artist.

VALENTINE

The space race did not feature only male heroes but female heroines too. Prime among them was the Russian cosmonaut Valentina Tereshkova, the first woman to fly in space. In 1963 Tereshkova spent three days in space during which she completed forty-eight orbits of Earth. Widely praised for her feat, Tereshkova was singled out by Evelyne Axell as an iconic independent woman. As we have seen, Axell was a fierce advocate of female emancipation in her work. Through the depiction of sexually charged women, often naked or in enticing poses, Axell reclaimed the female body as an instrument to further the feminist cause, as seen in *The Pretty Month of May* (page 114).

Space has the potential to further female emancipation

In *Valentine* (1966; opposite) the artist marries her liking for sexually liberated women with the heroic gestures of the first female cosmonaut, a pioneer in women's emancipatory struggle according to Axell. In the assemblage-painting *Valentine*, Tereshkova is depicted as a stylized white silhouette. Set against a gilded backdrop, *Valentine* is endowed with a larger-than-life aura. A helmet hung on the left of the painting links the white-profiled *Valentine* to her duties in space. It's not a real helmet, just a toy belonging to Axell's son Philippe, but it is displayed like a trophy to remind the viewer that space has the potential to further female emancipation.

Evelyne Axell
Valentine, 1966
Oil on canvas, zipper
and helmet, 133 x 83 cm
(52⅓ x 32⅝ in.)
Tate Modern, London

**No facial details are
retained, just a sleek
silhouette with a zip
running down the centre
of her body. Intended to
be zipped and unzipped
at the viewer's leisure,
Valentine is ready to
show off her sensuous
forms hidden under
the spacesuit.**

In 1969 Axell returned to the theme of space travel in a
performance, which subversively explored nudity as an expression
of sexual liberation. A mysterious woman, naked except for an
astronaut's helmet to conceal her identity, was chaperoned by Axell,
who then proceeded to slowly clothe her. Starting with underwear,
Axell endowed the performance with a seductive charge. Later,
the woman was revealed as the wife of a well-known collector and
known by many in the audience. With *Valentine* first and then the
performance, Axell pointed to the potential of space as a place
where social and gender hierarchies could be overturned.

NO COKE, JUST ROCKETS

The Austrian artist Kiki Kogelnik, described by the composer Morton Feldman as the 'love goddess of Pop art', preached the beauty of the space race. Tinged with utopian overtones, Kogelnik's understanding of space was filled with enthusiasm and ambition for the novelties that an extra-terrestrial dimension could bring.

Space is brought closer to home by Kogelnik's euphoria around scientific and technological progress

Declaring: 'I'm not involved with Coca-Cola. I'm involved in the technical beauty of rockets, people flying in space and people becoming robots,' she made clear that technological progress over

Kiki Kogelnik
Outer Space, 1964
Oil and acrylic on canvas,
182.9 x 137.2 cm
(72 x 54 in.)
Kiki Kogelnik Foundation,
Vienna and New York

Here two figures float
with ease in a silver
polka-dot expanse,
synonymous with
distant places and
far-away spaces.

Kiki Kogelnik
War Baby, 1972
Oil and acrylic on canvas,
185.4 x 124.5 cm
(73 x 49 in.)
Kiki Kogelnik Foundation,
Vienna and New York

**This work is part of a
series in which Kogelnik
gives shape to the
emancipated woman.
The female silhouettes
were appropriated from
fashion shoots and
advertisements.**

consumption was her primary interest. And she made this manifest
in works like *Outer Space* (1964; opposite).

Kogelnik went on to suggest: 'Everybody is an astronaut. You all
live aboard a beautiful little spaceship called Earth.' A reality that
is beyond most people's reach, space is brought closer to home by
Kogelnik's euphoria around scientific and technological progress.
Merging a psychedelic enthusiasm for space with a growing interest
in mechanization and robots, Kogelnik dehumanized her figures.
Her working method consisted of tracing the contours of bodies
lying on the floor – often her friends – and then making cut-out
figures from the tracings. Transferring the outlines onto a canvas or
converting them into vinyl silhouettes left the bodies with no real
bodily substance and just a flimsy skin. The insubstantiality of her
figures points to a darker side of the general enthusiasm for space,

which Kogelnik described as: 'Technological progress, however inextricably linked with the promise of happiness made by the new economy, has a high price: the loss of one's own body, which becomes a virtual carrier of the technological.'

While bodies are lost in space in *Outer Space*, through *War Baby* (1972; page 149) Kogelnik reclaimed the female body, giving it a more feminist connotation. Wearing a camouflage suit and with her arms flung wide open, *War Baby* poses as an archetypal anti-war cheerleader. Undermining the image of a woman relegated to the home in a patriarchal society, *War Baby*, aspired to debunk trite feminine clichés. Kogelnik's ultimate aspiration for her art was to create paintings, 'neither masculine nor feminine'. She explained: 'My feminist contribution rather is my work as such and my lifestyle, but not the artistic content.'

Tiger Tateishi
Meiji Centennial, 1964
Oil on canvas
130.3 x 162 cm
(51¼ x 63¾ in.)
Private collection

The work is virtually divided in two sections. The lower and most extensive part is dedicated to a fantastical extraterrestrial conquest, while the red band at the top is grounded in contemporary Japanese society.

A TIGER IN SPACE

Tateishi Koichi (known as Tiger Tateishi from 1968) adopted the tiger as his hallmark motif. Including the animal in most of his paintings, which departed from a comic-strip aesthetic, he reflected on Japan's recent history, including the American nuclear attacks and the import of American customs and goods in post-occupation Japan.

Attached like astronauts to a spacecraft, the tigers bring their flaming anger to outer space

In *Meiji Centennial* (1964; opposite) Tateishi propelled his trademark tigers into space. Attached like astronauts to a spacecraft, they bring their flaming anger to outer space. In contrast with the space race, into which Tateishi's tigers attempt to insert themselves, is a set of portraits in a band at the top of the painting. Featuring a line-up of noteworthy figures from Japan's past and recent history, these include, from left to right: the actor Toshiro Mifune, the US General Douglas MacArthur, Emperor Showa, Saigo Takamori and Emperor Meiji, whose centennial celebrations were set for 1968.

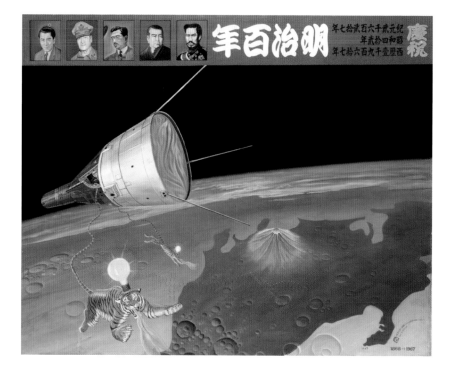

KEY WORDS

Cold war, space race, astronauts, cosmonauts, female
 emancipation, space exploration, Sputnik

KEY FIGURES

Yuri Gagarin, Alan Shepard, Gordon Cooper, Valentina Tereshkova

KEY ARTISTS

Joe Tilson, Gerald Laing, Martial Raysse, Evelyne Axell,
 Kiki Kogelnik, Tiger Tateishi

POP ON
THE ROAD

-

We were riding the motorcycle and wearing spurs . . .
and we were going across John Ford's America

-

Peter Fonda

1969

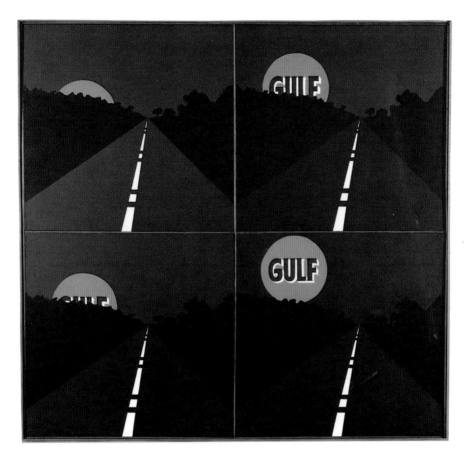

It was drizzling and mysterious at the beginning of our journey.
I could see that it was all going to be one big saga of the mist.
'Whooee!' yelled Dean. 'Here we go!' And he hunched over the
wheel and gunned her; he was back in his element, everybody
could see that. We were all delighted, we all realized we were
leaving confusion and nonsense behind and performing our one
and noble function of the time, move. And we moved!

Allan D'Arcangelo
Full Moon, 1962
Acrylic on canvas, 166 x
157.5 cm (65½ x 62 in.)
Virginia Museum of Fine
Arts, Richmond

**The stark and hard-edged
nature of D'Arcangelo's
highway paintings has
been associated with the
extreme abstract forms
of Minimalism.**

Moving was the premise of Jack Kerouac's cult novel *On the Road*
published in 1957. A romance of the American highway, it was
shaped around Kerouac's first-hand experience of travelling across
the country. Quickly gaining a legendary status, *On the Road*
embodied the quest for individual freedom and liberty experienced
by many young people at the time. The highway and its adjoining
attribute, the car, were reimagined as gateways leading to a new
America, where traditional familial hierarchies could be undone.
The highway became synonymous with the opening up of new
prospects for the rebellious younger generations.

On the Road played a key role in spreading the values of the Beat
generation, a bohemian group of artists, musicians and poets. The
West Coast, and San Francisco in particular, became the hub of
these seismic societal changes affecting young people worldwide.
It was in San Francisco that the renowned hippie movement first
developed, and it was in the Bay area where the use of LSD and
other psychedelic drugs came to the fore as young people rebelled.

The car – the quintessential emblem of the American Dream

Here we focus less on the hippie phenomenon and more on
the highway and the car as symbols of a changing landscape that
affected younger and older generations alike. While those coming
of age turned to the romance of the highway promoted by Kerouac
and his peers, others by contrast saw the car as the quintessential
emblem of the American Dream. Ownership of a car fulfilled one
of the biggest desires towards mobility in America and Europe,
as well as showing that its owner belonged to the middle classes.
Sanctioning both status and the freedom of movement, the car was
an aspirational symbol turned into a concrete reality for many in
the post-war years. Artists in America and abroad were well aware
of the social and cultural significance of the car and the highway
and went on to depict both extensively, revealing the positive

and negative connotations that these legendary symbols came to assume in the post-war imagination.

A GULF MOON RISES ON THE ROAD

Allan D'Arcangelo and a group of friends embarked on a road trip resembling the one described by Kerouac in his novel. This voyage along America's wide and seemingly endless highways proved extremely influential on D'Arcangelo who went on to depict the empty and untarnished roads extending across the country. Cool and intentionally detached, D'Arcangelo's representation of the highway devoid of human presence is sinister at times. With no clear departure point or ending, the unspecific highways depicted by the artist become generic stand ins for any possible destination.

'Once you "got" Pop, you could never see a sign the same way again'

D'Arcangelo gave signage a prominence in otherwise undetailed scenes, as clearly shown in *Full Moon* (1962; page 154). The canvas is divided into four equal parts, each depicting an empty highway at night. The road and the surrounding nature have been blacked out, with only the dividing white lines at the centre of the four highways to pave the way. However, the full moon peeking through the trees is the true focus of the painting. Relinquishing the typical white lunar surface, D'Arcangelo presents us with a moon turned into a gasoline logo.

The artist merged the moon with Gulf, an illuminated sign borrowed from the petroleum company of the same name, pointing to the overwhelming power of commercial signage in the contemporary visual landscape. This stance resonated in turn with Robert Venturi and Denise Scott Brown's *Learning from Las Vegas* (1972), a groundbreaking study on the transformation of architecture and urbanism in the face of consumer culture They claimed: 'The familiar Shell and Gulf signs stand out like friendly beacons in a foreign land.'

The hard-edged elongated perspective, which D'Arcangelo adopted in all four scenes, was meant to align the viewer's experience with that of the driver, speeding along the highway. And in this context the Gulf sign, as described by Venturi and Scott Brown, stood out as a beacon of instant recognizability, offering

a sense of reassurance to the adventurous driver, as well as drawing him into the commercial world. As Warhol expressed:

> The farther west we drove [to California, autumn 1963], the more Pop everything looked on the highways. Suddenly we felt like insiders because even though Pop was everywhere – that was the thing about it, most people still took it for granted, whereas we were dazzled by it – to us, it was the new Art. Once you 'got' Pop, you could never see a sign the same way again. And once you thought Pop, you could never see America the same way again.

PUZZLING PUBLICATIONS AND PETROL STATIONS

The foreshortened perspective adopted by D'Arcangelo to give the viewer the impression of driving a speeding car was a common stylistic device for Pop artists. Ed Ruscha, the West Coast painter, printmaker and photographer, was one such artist. Like D'Arcangelo, Ruscha was also drawn to the highway and its vernacular architecture. The petrol station, a modern landmark and a beacon of the kind described by Venturi and Scott Brown, proved very influential on Ruscha's oeuvre. In 1962 while travelling between Los Angeles and his family home in Oklahoma City, Ruscha documented photographically the new and old petrol stations he encountered along Route 66. The photographs were then assembled in his now iconic artist book *Twenty Six Gasoline Stations* (1963). Commenting on this experience, Ruscha claimed:

> I am interested in unusual kinds of publications. The first book came out of a play with words. The title came before I even thought about the pictures. I like the word 'gasoline' and I like the specific quality of 'twenty-six.' If you look at the book you will see how well the typography works – I worked on all that before I took the photographs . . . it is not a book to house a collection of art photographs – they are technical data like industrial photography. To me, they are nothing more than snapshots.

The deadpan black-and-white images, which form the core of Ruscha's book, went on to inspire one of his most recognizable pictorial works: *Standard Station, Amarillo, Texas* (1963; pages 158–9). The focus, as the title of the work suggests, is a modern, generic Standard petrol station as standard as its branded name. The colours are bold but flat through Ruscha's use of a deadpan graphic approach, a style partly arising from his training as a commercial

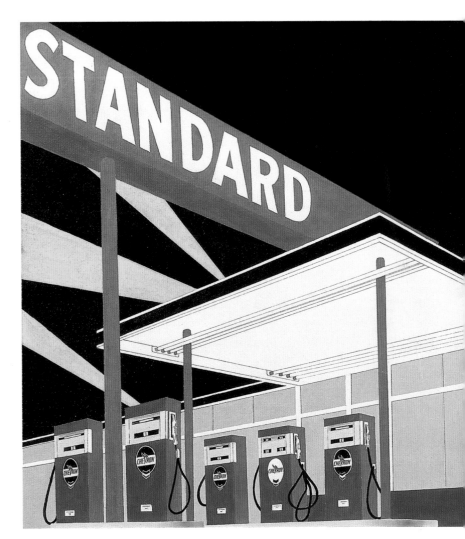

Ed Ruscha
Standard Station, Amarillo,
Texas, 1963
Oil on canvas, 165.1 x
308.6 cm (65 x 121½ in.)
Hood Museum of Art,
Dartmouth College,
Hanover, New Haven

The petrol station appears
as a latter-day monument:
the three beaming lights
illuminating it from the
rear reinforce the station's
image as the quintessential
highway landmark.

artist at the Chouinart Art Institute in Los Angeles. Constructed as a set of clearly defined geometric blocks the petrol station in *Standard Station, Amarillo, Texas* accentuates the exaggerated elongated perspective already explored by D'Arcangelo. Speeding past the petrol station, the imaginary car is set in a wholly man-made environment devoid of any natural features. Ruscha continued to explore this motif in a series of prints, where the iconic petrol station was revisited through different processes and nuances.

The artist George Segal, best known for his life-size sculptural *tableaux vivants*, focused on the same subject in *The Gas Station* (1963). A recreation of a petrol station as with the one depicted by Ruscha, Segal's work is endowed with sinister overtones not unlike those in D'Arcangelo's *The Full Moon*. Two figures perform menial tasks: one awaits the arrival of a customer while the other attends to some duties in a separate office space. The human figures, based on live models retain the ghostly whiteness of the plaster casts from which they were moulded. By contrast the surrounding objects and furnishings are lifted directly from the everyday, maintaining a sense of reality in contrast with the otherworldliness of the human casts. To highlight the growing sense of alienation experienced by individuals in urban environments, the casts' vulnerability is reinforced by the mundane nature of the surrounding objects. A Coca-Cola dispenser stresses commerce's tangibility in comparison with the imaginary human forms.

AMERICAN DREAMING

Raising awareness rather than falling for the lure of commercial brands and their signage, Segal was critical of the highway and its emblems. He shared this a position with Robert Indiana, whose work is rooted in his childhood memories of pinball slot machines and the nomadic existence led by his parents. Hoping to speak to a large audience through using cheap commercial emblems, he aspired to be a people's painter. By adopting a simple vocabulary borrowed from road signs and commercial logos, the artist worked, in his words, 'on the waterfront where signs are much more profuse than trees (farewell, Nature) and much more colourful than people (farewell, Humanity)'. A comment on the profusion of signage overtaking both nature and humanity, Indiana's *American Dream* series of paintings is full of distrust.

As stated by Indiana, the third painting in his *Dreams* series, *The Red Diamond American Dream #3* (1962; opposite), acts as as 'a comment on the superficiality of American life'. Mixing

Robert Indiana
The Red Diamond
American Dream #3, 1962
Oil on canvas, 259.1 x
259.1 cm (102 x 102 in.)
Van Abbemuseum,
Eindhoven

**The words 'tilt', 'all' and
'take' allude to the all-
pervasive ideals of
the American Dream.**

geometrical forms with graphic ones, the artist mimics the flickering
structure of a pinball machine, with words and concepts bouncing
off each other. For instance, the upper circle containing numbers
of prominent American highways, including the famous Route 66,
represents for Indiana the ideals of freedom and liberty cherished by
countercultural movements, as well as on a more autobiographical
level hinting at his father leaving the family and moving westwards
along Route 66.

Richard Hamilton
*Hommage à Chrysler
Corp*, 1957
Oil, metal foil and
collage on wood,
147.9 x 107.4 x 6.7 cm
(58¼ x 42¼ x 2⅝ in.)
Tate, London

**Hamilton combined the
appropriation of images
from the mass media
with a technique vaguely
reminiscent of Cubist
fragmentation.**

HOMAGE TO CHRYSLER

Thus far the focus has been on the American highway, the
proliferation of signage that came with it and the automobile culture
it promoted viewed through the lens of likeminded American Pop
artists, keen to acknowledge both its myths and its flaws. The road
and the car, both metaphors for movement and status symbols,
were, however, widely redeployed by European Pop artists.
Exemplary is Hamilton's *Hommage à Chrysler Corp* (1957; above)
where the loose rendering of a car and a woman leaning on it, point
to the correlation between the two. Presented on a par, the two
objects of desire – a car and a woman – are, following the logic
of advertising, inextricably tied. The 'Corp' in the title ironically
reinforces this concept, on the one hand hinting at a 'corporation' in
the business sense, and on the other hand playing with the French
word *corps* (body) or corpse in English. The bodily reference applies
here to both the car and the woman, which appear to be equally
dismembered. The bonnet of the car with its pinkish hue marks the
automobile's presence, while the bright red lips peeking from the

neutral beige background suggest the remains of a hyper-sexualized femininity. Furthermore the reference to the Chrysler Corporation points, like Coca-Cola, to the hegemonic force of American brands in the post-war era.

AUTO-STOP ON THE WAY TO FEMALE LIBERATION

Evelyne Axell's *Auto-Stop* (1965; below) also relates a woman to the automotive landscape. Axell, as previously discussed on pages 112, 114–15 and 146–7, visualized woman's emancipation through the liberation of the female body. In *Auto-Stop* she draws attention once again to the naked female body as a symbol of emancipation, and does so by intruding on the testosterone-charged realm of the highway. Gazing at an empty highway, not dissimilar to the ones depicted by D'Arcangelo, Axell's suavely posed woman overlooks the road with confidence. Sporting a helmet, the female character suggests a readiness to take charge of a vehicle like her male peers. The highway here stands as a site of escape, where gender disparities can be finally broken down.

Evelyne Axell
Auto-Stop, 1965
Oil on canvas, 98 x 146
cm (38⅝ x 57½ in.)
Private collection

It has recently been discovered that underneath this painting, there is an earlier version featuring a car.

-

Axell's suavely posed woman overlooks the road with confidence

-

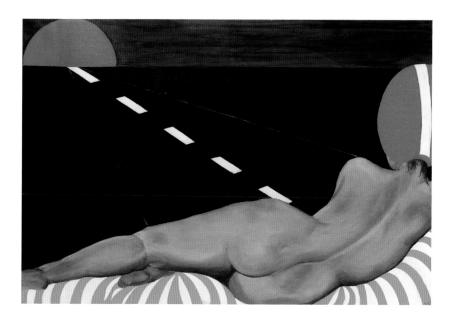

A TRAVEL-SIZE COAT FOR ELEVEN

As discussed throughout this chapter the symbolic association of movement with a newfound liberty invoked by Kerouac in *On the Road* resonated with many Pop artists. However, all the works we have considered so far depict the experience of movement, but do not *actually* move. French artist Nicola L's *Red Coat* (1969; page 152 and opposite) is entirely premised on movement and nomadism, embracing the longing for freedom and liberty and overturning hierarchical norms.

In 1970 the artist Nicola L attended with a group of friends a music festival taking place on the Isle of Wight between 26 and 31 August. Widely recognized as one of the most iconic concerts of its time, with an attendance of over 600,000 people, it rivalled its American counterpart, Woodstock. The line-up included Jimi Hendrix, The Doors, Joan Baez, as well as Nicola L's friends the Brazilian musicians Gilberto Gil and Caetano Veloso.

Concerned by the high chance of rain that a place like the Isle of Wight posed, the artist created a giant raincoat for herself and her friends. Made out of red plastic, the coat was endowed with a double function: to shelter the group from potential showers and to keep them united amid the festival crowds. As it turned out, the weather proved ideal for an open-air festival: sunny and extremely hot, it spared the crowds from bothersome rain. However, it was less ideal for the inhabitants of the *Red Coat*, who quickly discarded the heated cover-up and walked around naked. Having partially fulfilled its function at the Isle of Wight, the *Red Coat* promptly shifted from a ready-to-wear festival coat into a portable work of art.

-

The *Red Coat* was turned into the quintessential nomadic global citizen

-

On a mission to take her *Red Coat* to as many different contexts and locations possible, Nicola L travelled the world with the coat squeezed into a suitcase. The coat was emblazoned with a distinct sense of flux and transience as intrigued, puzzled and sceptical passers-by were asked to step into the *Red Coat* and temporarily take charge of its whereabouts. From the sandy beaches of Ibiza to the streets of New York, Amsterdam, Barcelona and Ghent, the *Red Coat* was turned into the quintessential nomadic global citizen. However, what changed most significantly the nature of the coat was not its global passport but the addition of the subtitle

Nicola L
Red Coat, 1969
Vinyl, dimensions variable
Performance with
Fernando Arrabal on
Broadway, New York

A wearable and mobile shelter consisting of eleven hoods, twenty-two arm slits and one single skirt uniting them all, the *Red Coat* was deemed the perfect festival outfit.

'Same Skin for Everybody'. This motto indicated the artist's desire that the coat should break down all gender and social barriers and transformed the *Red Coat* from a quirky piece of festival clothing to a fully fledged critical artwork. The nomadic spirit of Nicola L's *Red Coat* was in tune with the countercultural ethos overtly embraced by the hippie movement. As a carrier of freedom and equality, the *Red Coat* visibly performed the youthful enthusiasm so often associated with the cult of the car and the highway.

KEY WORDS

Highway, car, counter-culture, advertisement, road trip, petrol station, nomadism, *On the Road*, Coca-Cola, American Dream, Chrysler, Beat generation

KEY FIGURES

Jack Kerouac

KEY ARTISTS

Allan d'Arcangelo, Ed Ruscha, George Segal, Robert Indiana, Richard Hamilton, Evelyne Axell, Nicola L

1953
- *Playboy* is released.
- Joseph Stalin dies.

1956
- The exhibition 'This is Tomorrow' opens at the Whitechapel Gallery in London.

1957
- The Soviet Union launches into space Sputnik 1, followed by Sputnik 2 a month later.
- Jack Kerouac's *On the Road* is published.
- European Economic Community (EEC) is established.

1959
- Vietnam War begins.

1960
- John F. Kennedy is elected President of the United States of America.
- Oral contraceptives approved in the USA.

1961
- Soviet cosmonaut Yuri Gagarin becomes the first man in space.
- The Beatles perform for the first time at the Cavern Club in Liverpool.
- Berlin Wall is constructed.

1963
- John F. Kennedy is assassinated.

1965
- Malcolm X is assassinated in New York.
- Race riots in Los Angeles.
- Death of Winston Churchill.
- Large scale demonstrations against the Vietnam War.

1966
- Mao Zedong launches the Great Proletarian Cultural Revolution in China.

1967
- Six-Day War between Arabs and Israelis.
- Military coup in Greece.
- Che Guevara is captured and killed by Bolivian troops.

1969
- Neil Armstrong is the first man to set foot on the moon.
- The Woodstock Music and Art Fair takes place outside New York.
- Atrocities perpetrated by American troops in Vietnam are revealed in an article published by *Life* magazine.
- On 15 October fifteen million people protest against the Vietnam War in the USA.

1970
- A wave of demonstrations led by the women's liberation movement.
- Isle of Wight Music Festival.
- Death of Charles de Gaulle.

1971
- The Union of Arab Republics is formed by Egypt, Syria and Libya.
- India declares war on Pakistan.

1972
- Bloody Sunday in Northern Ireland.

1973
- US troops leave Vietnam.
- World oil crisis.

GLOSSARY

Abstract Expressionism
A movement developed by American painters in the 1940s and 1950s. The Abstract Expressionists, such as Jackson Pollock and Willem de Kooning, were mostly based in New York City. They aimed to create an expressive and emotional art based on non-representational abstract forms.

Appropriation
The artistic practice of borrowing pre-existing images from another context and subjecting them to little or no transformation.

Assemblage
The practice of making art by assembling disparate objects.

Beat generation
A literary movement started by a group of young authors based in San Francisco in the 1950s. It later encompassed rebellious youth movements.

Benday dots
Used in a printing process whereby small coloured dots are closely spaced, widely space or overlapping to produce a certain optical effect, as in *Look Mickey* by Roy Lichtenstein (pages 31–2) and *Lincoln Convertible* by Gerald Laing (pages 54–5).

Capitalist Realism
A movement founded in Berlin in 1963. Like American Pop Art the artists associated with the movement (Gerhard Richter and Sigmar Polke, among others) adopted a vocabulary of images and themes drawn from the mass media. However, unlike American Pop Art, they were engaged with the particular economic, social and political situation of post-war Germany.

Collage
The term collage derives from the French word *papier collé*. It is used to describe the artistic technique of arranging and pasting paper and other ephemera onto different supports.

Cubism
An approach to the representation of reality ushered in by Georges Braque and Pablo Picasso. Premised on viewing a subject or an

object from multiple viewpoints at the same time, Cubism is characterized by flat abstract and fragmented planes.

Equipo Crónica

Founded in Valencia by artists Rafael Solbes, Manuel Valdés and Juan Antonio Toledo in 1964. The group opposed abstract tendencies and adopted a figurative style that referenced everyday life. The association lasted up until 1981.

Feminist art

Describes the art made by female practitioners in light of feminist ideals and theories.

Figurative art

In modern art, a form that refers closely to the real world and particularly to the human figure.

Futurism

In 1909 the Italian poet Filippo Tommaso Marinetti launched the Futurist movement with the Manifesto of Futurism. The Futurists vehemently rejected the past and embraced the modern world. Speed, technology and industry were key subjects.

Hard-edged painting

A style of painting in which forms and shapes are clearly delineated.

Hippie movement

The hippie movement originated as a youth movement in San Francisco in the early 1960s, later spreading across the world. It espoused communal living, artistic experimentation, spirituality (influenced by eastern religion) and the use of hallucinogenic drugs. It is now closely associated with subcultural and countercultural movements of the 1960s.

Installation

The term used to describe a construction made out of miscellaneous materials designed for a specific place. Installation art is often temporary and usually requires the participation of spectators.

Lineoleography or linocut

Describes an artistic technique popular among printmakers. Like a woodblock the linoblock is carved to produce a raised surface that can be inked and printed.

Minimalism
A form of pure abstraction in painting and sculpture based on simple geometric forms, such as the square and the rectangle.

Mass media
Means of communication that have the capacity to deliver information to millions of people, such as television and newspapers.

Nouveau Réalisme
A French movement founded by the critic Pierre Restany in 1960 that was premised on the assemblage of pre-existing objects and materials.

Photomontage
A collage made with photographs. Photomontages are often used to raise political awareness and manifest dissent.

Saqqakhane (Spiritual Pop)
A term used to characterize a group of Iranian artists who starting in the early 1960s integrated Shiite folk art into their practice.

Silkscreen (screen-printing)
A process whereby ink is passed through a woven mesh onto a prepared surface, creating a stencilled pattern.

Socialist Realism
A form of realism imposed on Russian artists by Stalin following his rise to power in 1924.

Sots Art
A term coined by the artists Komar & Melamid in the early 1970s. Short for Socialist Art, it ironically combines the western notion of Pop Art with the Soviet-sponsored Socialist Realism.

Tableau vivant
A posed motionless group representing a well-known work of art.

Viet Cong
A member of the Communist guerrilla force that was active in Vietnam, during the Vietnam War (1954–76).

SELECTED READING

Alloway, Lawrence, Reyner Banham and David Lewis, *This is Tomorrow*, exh. cat. (Whitechapel Gallery, London, 1956)

Amaya, Mario, *Pop as Art: A Survey of the New Super-Realism* (Studio Vista, London, 1965)

Bezzola, Tobia and Franziska Lentzsch, *Europop*, exh. cat. (Kunsthaus Zürich, Zurich, 2008)

Collins, R. Bradford, *Pop Art: the Independent Group to Neo Pop, 1952–90* (Phaidon, London, 2012)

Crow, Thomas, *The Long March of Pop: Art, Music, and Design, 1930–1995* (Yale University Press, New Haven/London, 2014)

Foster, Hal, *The First Pop Age: Painting and Subjectivity in the Art of Hamilton, Lichtenstein, Warhol, Richter, and Ruscha* (Princeton University Press, Princeton/Oxford, 2012)

Francis, Mark, ed., *Pop* (Phaidon, London, 2005)

Francis, Mark, ed., *Les années pop, 1956–1968*, exh. cat. (Centre Georges Pompidou, Paris, 2001)

Goldfarb Marquis, Alice, *The Pop! Revolution: how an unlikely concatenation of artists, aficionados, businessmen, collectors, critics, curators, dealers, and hangers-on radically transformed the art world* (MFA Publications, Boston, 2010)

Harrison, Sylvia, *Pop Art and the Origins of Post-Modernism* (Cambridge University Press, New York, 2001)

Haskell, Barbara, *Blam!: The Explosion of Pop, Minimalism, and Performance 1958–1964*, exh. cat. (Whitney Museum of American Art, New York, 1984)

Kries, Mateo and Mathias Schwartz-Clauss, *Pop Art Design*, exh. cat. (Vitra Design Museum, Weil am Rhein, 2012)

Livingstone, Marco ed., *Pop Art*, exh. cat. (Royal Academy of Arts, London, 1991)

Livingstone, Marco, *Pop Art: A Continuing History* (Thames & Hudson, London, 1990)

Lippard, Lucy, *Pop Art* (Thames & Hudson, London, 1965)

Madoff, Steven Henry, *Pop Art: A Critical History* (University of California Press, Berkeley/London, 1997)

Morgan, Jessica and Flavia Frigeri, eds, *The World Goes Pop*, exh. cat. (Tate, London, 2015)

Sachs, Sid and Kalliopi Minioudaki, *Seductive Subversion: Women Pop Artists, 1958–1968* (University of the Arts, Philadelphia, 2010)

Stief, Angela and Martin Walkner, ed., *Power Up: Female Pop Art* (Kunsthalle Wien, Vienna, 2010)

Weinhart, Martina, ed., *German Pop*, exh. cat. (Schirn Kunsthalle, Frankfurt, 2014)

INDEX